FEDERICO ZERI (Rome, 1921-1998), eminent art historian and critic, was vice-president of the National Council for Cultural and Environmental Treasures from 1993. Member of the Académie des Beaux-Arts in Paris, he was decorated with the Legion of Honor by the French government. Author of numerous artistic and literary publications; among the most well-known: *Pittura e controriforma*, the Catalogue of Italian Painters in the Metropolitan Museum of New York and the Walters Gallery of Baltimora, and the book *Confesso che ho sbagliato*.

Work edited by FEDERICO ZERI

Text
based on the interviews between
FEDERICO ZERI AND MARCO DOLCETTA

This edition is published for North America in 2000 by NDE Publishing*

Chief Editor of 2000 English Language Edition
ELENA MAZOUR (*NDE Publishing**)

English Translation
SUSAN SCOTT

Realization
ULTREYA, MILAN

Editing
LAURA CHIARA COLOMBO, ULTREYA, MILAN

Desktop Publishing
ELISA GHIOTTO

ISBN 1-55321-011-5

Illustration references

Alinari Archives: 1, 2-3, 4a, 6, 7as-d, 8-9, 10, 11, 12s, 13, 15a, 28bd, 30a, 31d, 44/IV-IX.

Alinari/Giraudon Archives: 7bs, 17bs, 19, 27, 28bd, 32-33b, 44/VIII, 45/III-VI-VII.

Antonello Idini: 4b.

Bridgeman/Alinari Archives: 16-17, 23as, 26, 38-39, 44/VII-X.

Giraudon/Alinari Archives: 22a, 29bd, 33b, 34s, 36as, 42s, 45/IX-XII.

Istituto Centrale per il Catalogo e la Documentazione: 4-5.

Luisa Ricciarini Agency: 17a, 28ad, 29s, 31as, 33as, 44/V-XII, 45/V.

Photographic Archive Pinacoteca Capitolina: 23bs, 43as.

RCS Libri Archive: 2a, 16, 17bd, 22b, 23bd, 26-27, 28s, 29ad, 30, 32-33a, 33ad, 34-35, 36as-bs, 37a, 40c, 40-41, 43cs-cd, 44/II-III-VI-XI, 45/I-II-IV-VIII-X-XI-XIV.

R.D.: 9d, 12ad-cd, 14, 15bs-bd, 18, 20, 21, 23ad, 31bs, 34db, 35, 36ad, 37b, 40as-ab, 41a-c-b, 42-43, 43b, 44/I, 45/XIII.

From *Tiziano Amor sacro e Amor profano*, Milan, 1995: 24-25.

Printed and bound by Poligrafici Calderara S.p.A., Bologna, Italy

* a registered business style of NDE Canada Corp.
15-30 Wertheim Court, Richmond Hill, Ontario
L4B 1B9 Canada, tel. (905) 731-1288

The captions of the paintings contained in this volume include, beyond just the title of the work, the dating and location. In the cases where this data is missing, we are dealing with works of uncertain dating, or whose current whereabouts are not known. The titles of the works of the artist to whom this volume is dedicated are in blue and those of other artists are in red.

TITIAN
SACRED AND PROFANE LOVE

SACRED AND PROFANE LOVE is the title usually given to one of Titian's great masterpieces, a jewel of the Galleria Borghese. It is a sublime work of art, fascinating in the mystery of its meaning. Questions

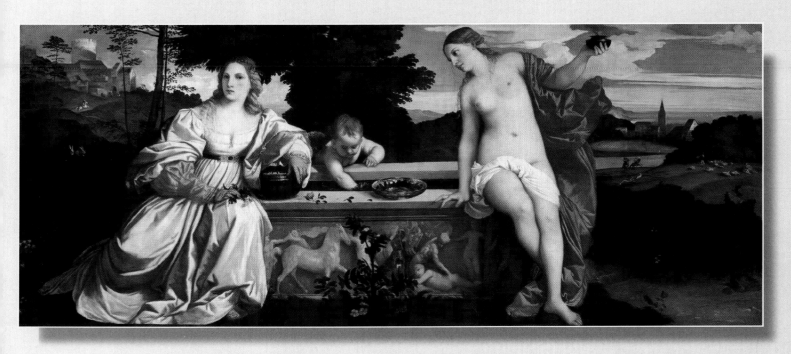

will always arise concerning its subject, unless some document surfaces to explain its content, which appears to be a Neoplatonic interpretation of classical elements, approached through the poetry of Petrarch.

A MYSTERIOUS ALLEGORY

SACRED AND PROFANE LOVE

1514-1515

● Rome, Galleria Borghese (oil on canvas, 118x279 cm)

● *Sacred and Profane Love* is a title given to the painting only in fairly recent times (Vasi, 1792). Called by critics by various other names (*Heavenly and Earthly Love*, *Artless and Sated Love*, etc.), it has always been the object of great attention and admiration on the part of the public and critics in Italy and abroad. The work is celebrated not only for its sublime aesthetic quality – it is considered one of the masterpieces of Titian's ear-

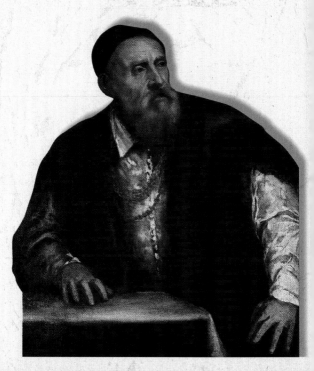

♦ SELF-PORTRAIT
(1550-1562, Berlin,
Staatliche Museen).
This signed self-portrait
shows Titian
as a mature man.

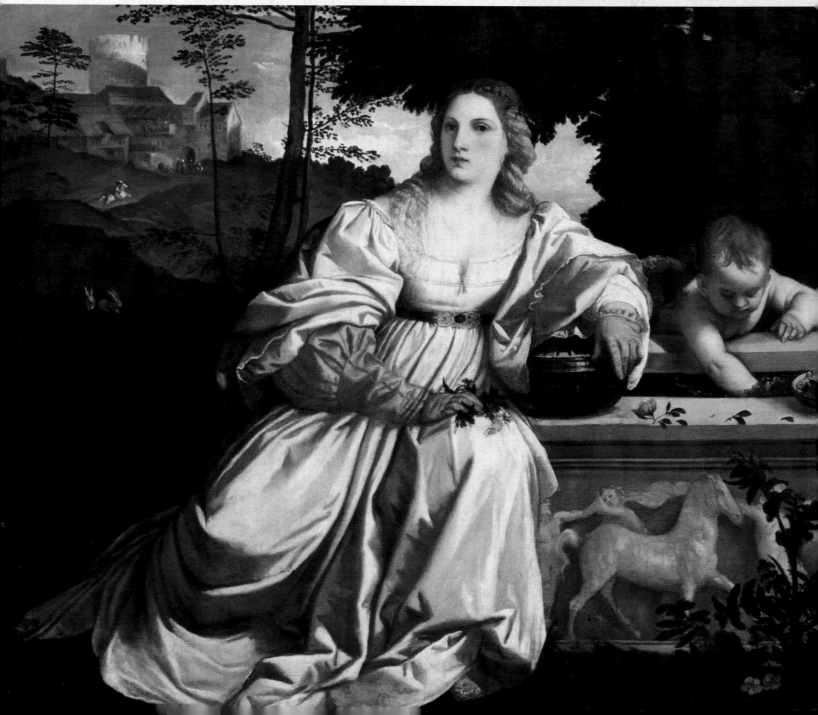

ly period – but above all for the aura of mystery which surrounds interpretation of its subject, and more generally, the entire history of the painting.

● The questions concern in particular the interpretation of the scene represented. The fact that the iconography of the work is composed of themes drawn from various literary sources does not facilitate an exhaustive explanation of a subject charged with symbolic meanings and historical and social references.

The painting represents a marble sarcophagus, decorated with a classical relief, into which a little Cupid dips his hand. On it are seated two women: the one on the left is dressed in a sumptuous sixteenth century Venetian costume; the other, practically nude, a cloak thrown over her left arm, holds a small urn or lamp, from which smoke rises. The scene is set in a vast, open mountain landscape with a fortified hill town on the left; leafy trees fill the center, while on the right sheep graze in the middle ground before a lake scene stretching into the distance. Small figures, some engaged in erotic pursuits, animate the picture.

◆ A DOWRY RESTORED
(1509, Venice, Archivio di Stato).
The document returns to Laura Bagarotto her dowry, which had been confiscated.

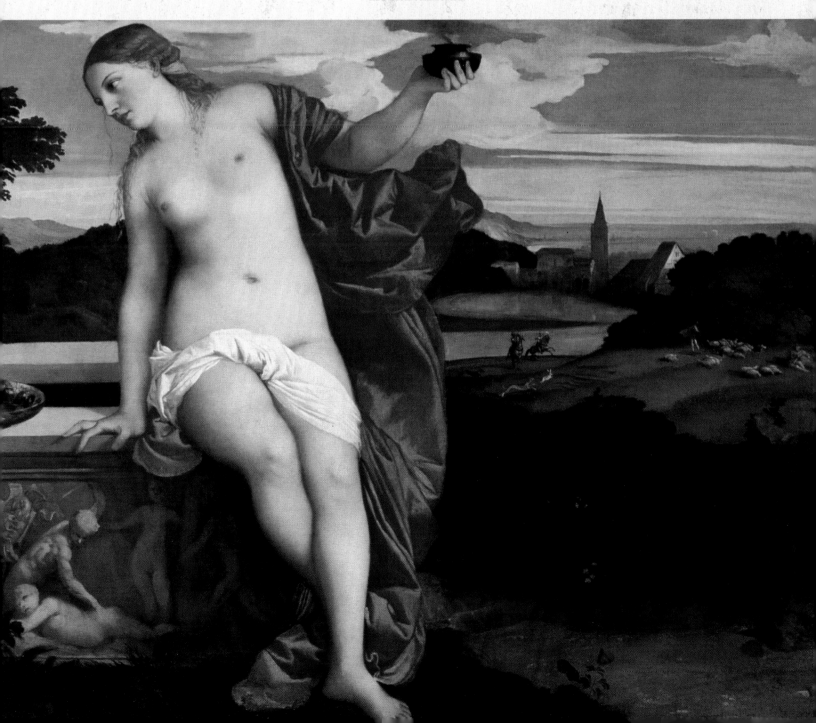

THE BORGHESE GALLERY

T he work hangs in the recently restored space of the Borghese gallery in Rome. Studies have not yet revealed how the painting came into the Borghese collection and when and how it came from Venice to Rome. It is probable that the picture, already in the first half of the sixteenth century, belonged to the Sfondrato family, aristocrats from Cremona, and in particular to Cardinal Paolo Emilio. Already an established collector of Venetian paintings, Sfondrato met Cardinal Baronio, a scholar of Early Christian art, who persuaded him to devote himself to the study of the early centuries of Christianity. As a result, the Sfrondato collection was sold in two separate phases (in 1597 and in 1601) to Cardinal Scipione Borghese, nephew of the future Pope Paul V.

♦ GIAN LORENZO BERNINI
Cardinal Scipione Borghese
(1632, Rome, Galleria Borghese).

● The painting's importance is confirmed by events surrounding the sale of the Borghese collection to the state of Italy at the end of the nineteenth century. During negotiations, the Borghese family offered to give up the sum of 3,600,000 lire, established for the transfer of the property, if only they could be allowed to keep *Sacred and Profane Love*. Concealed behind this proposal, which the State fortunately refused, was the wealthy Rothschild family, who wanted to buy the painting for 4,000,000 lire.

♦ THE PAINTING'S HOME
The entrance to the Galleria Borghese after its restoration in 1997. Right, the room where the picture hangs, seen before restoration.

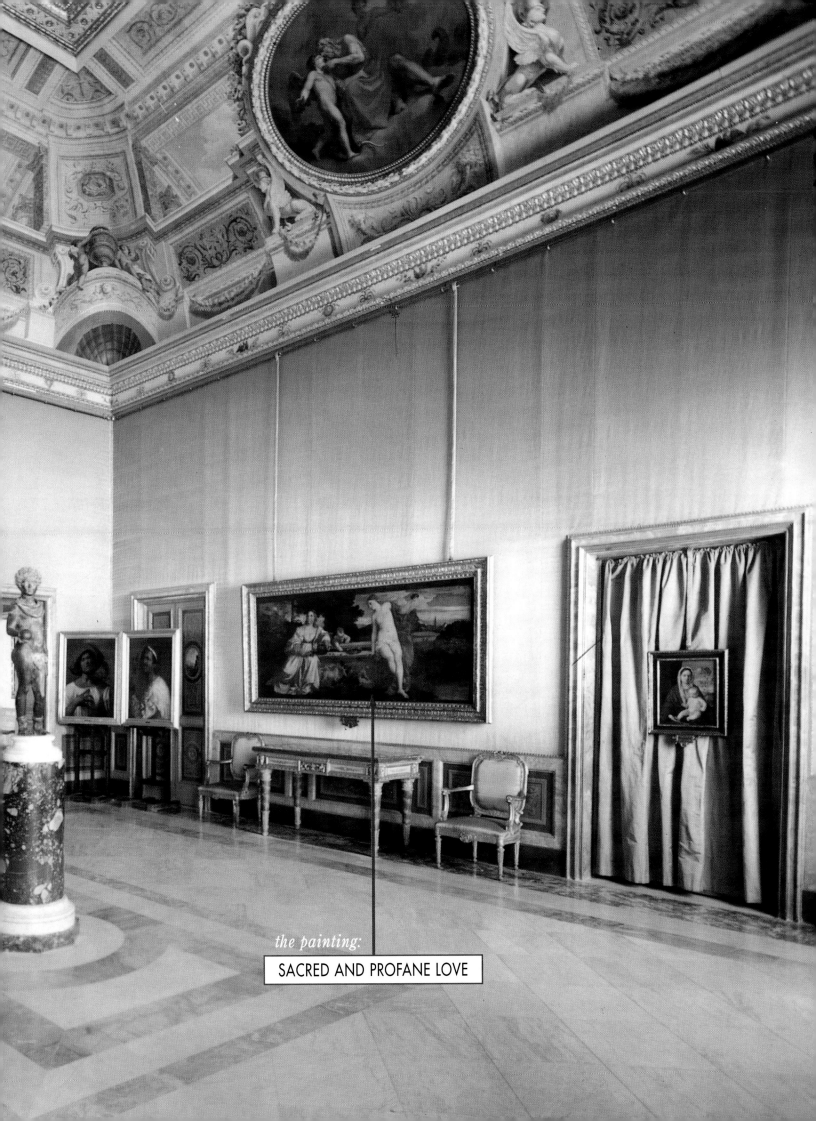

the painting:

SACRED AND PROFANE LOVE

HYPOTHESES FOR A PICTURE

Given the extreme difficulty in interpreting the iconography of the painting, scholars have offered various explanations, most of them linked to precise literary or philosophical sources. For Wickhoff (1895) the meaning of the picture is a persuasion to love, and its literary source would be the *Argonautica* by Valerius Flaccus, in which Venus (the nude woman) exhorts Medea to follow Jason. Hourticq (1917) and Friedländer (1938) see it as the illustration of an incident in the *Hypnerotomachia Poliphili* – a famous Renaissance text rich with symbolism – in which Venus returns to the sarcophagus of Adonis, the youth she loved, who was killed during a boar hunt. The subject would be an initiation into the mysteries of love, to

fer to Plato's *Symposium* and his theory of love. The nude figure would thus be the heavenly Venus holding in her hand the fire of divine love, while the dressed woman represents the earthly Venus, the embodiment of sensual beauty. Intermediary between the two realities is the little Cupid, and the two women would constitute the personificaton of two different degrees and ways of loving.

● Currently, the most plausible explanation is considered to be that of a marriage allegory, even if we are still far from having found a definitive solution to the intricate iconographical mystery. The two spouses can be identified as Niccolò Aurelio and Laura Bagarotto, the daughter of an eminent jurist condemned to death by the Serenissima for having sided with

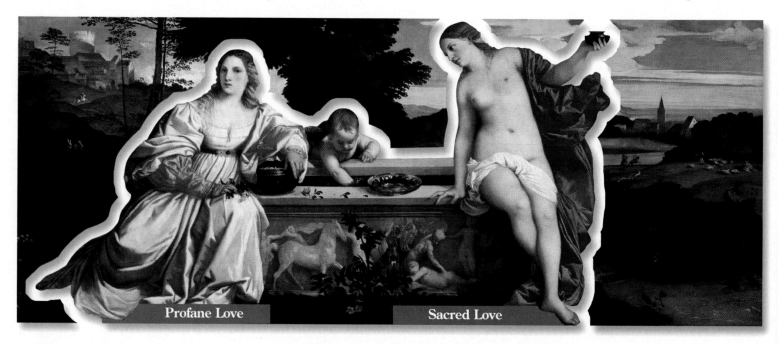

Profane Love

Sacred Love

which Venus, the figure on the right, tries to attract the richly dressed woman. Friedländer proposes to identify the dressed figure as Polia, protagonist of the *Hypnerotomachia*, and the arms on the sarcophagus as those of the Venetian Aurelio family. He posits that the painting could have been commissioned by Niccolò Aurelio, secretary of the Council of Ten of the Venetian Republic from 1509 to 1523 and a great friend of the man of letters Pietro Bembo, who probably suggested the subject.

● Other interpretations (Panofsky, 1939) place the painting in relationship with the passages from Bembo's *Asolani* which re-

the emperor in the crisis of 1509, and the widow of Francesco Borromeo, who had been imprisoned for the same reason. An item of historical information can help confirm this hypothesis. In 1509, Niccolò Aurelio himself restored to Laura her rich dowry that had been confiscated by the Venetian Republic, permitting her to marry again. *Sacred and Profane Love* would thus have been painted by Titian for the Aurelio-Bagarotto marriage, with a persuasive intent aimed at the widow. According to this allegorical significance, Love (represented by Cupid) and the nude Venus would have the task of persuading the bride, dressed in her sumptuous finery, to consent to the wedding.

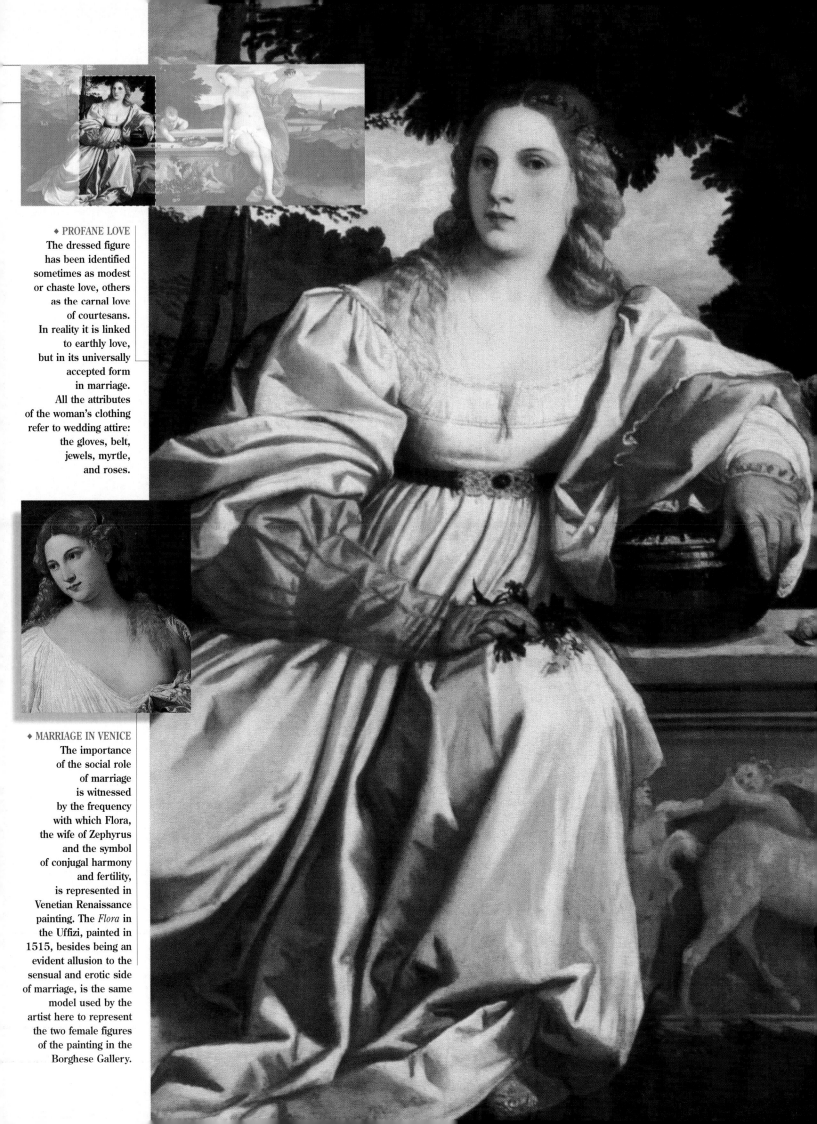

♦ PROFANE LOVE
The dressed figure has been identified sometimes as modest or chaste love, others as the carnal love of courtesans. In reality it is linked to earthly love, but in its universally accepted form in marriage. All the attributes of the woman's clothing refer to wedding attire: the gloves, belt, jewels, myrtle, and roses.

♦ MARRIAGE IN VENICE
The importance of the social role of marriage is witnessed by the frequency with which Flora, the wife of Zephyrus and the symbol of conjugal harmony and fertility, is represented in Venetian Renaissance painting. The *Flora* in the Uffizi, painted in 1515, besides being an evident allusion to the sensual and erotic side of marriage, is the same model used by the artist here to represent the two female figures of the painting in the Borghese Gallery.

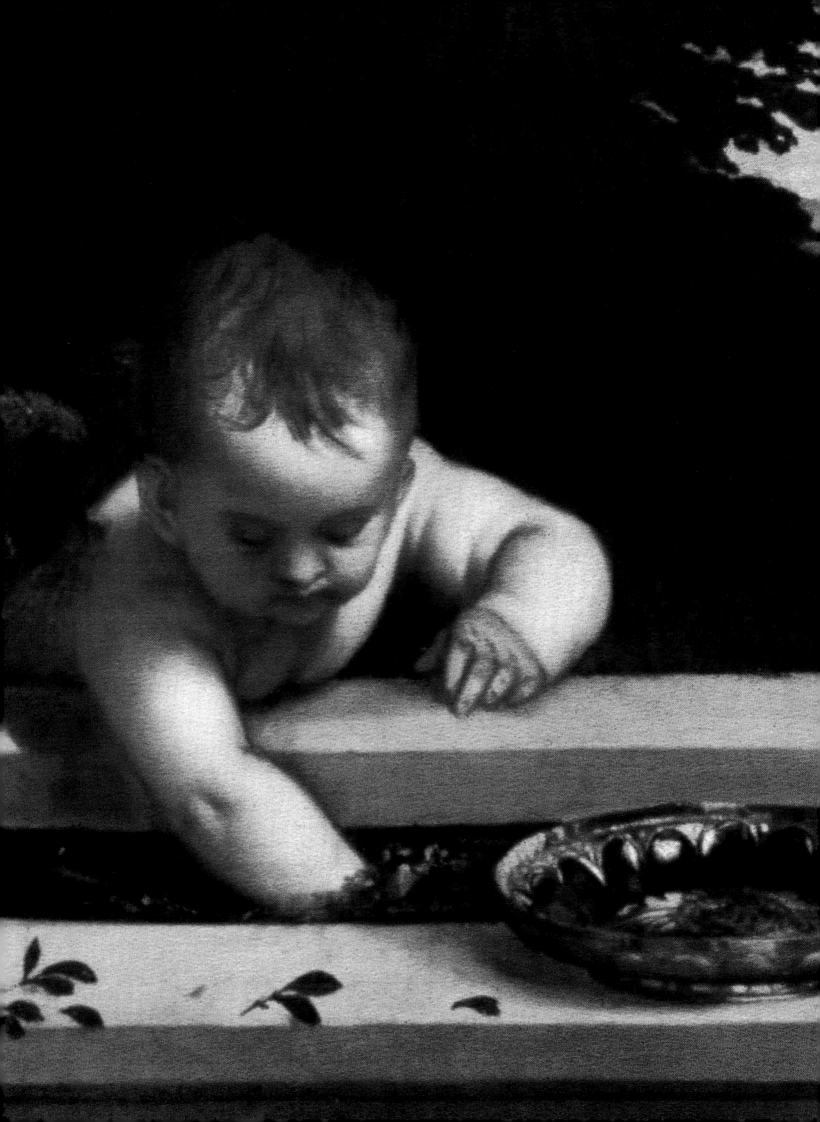

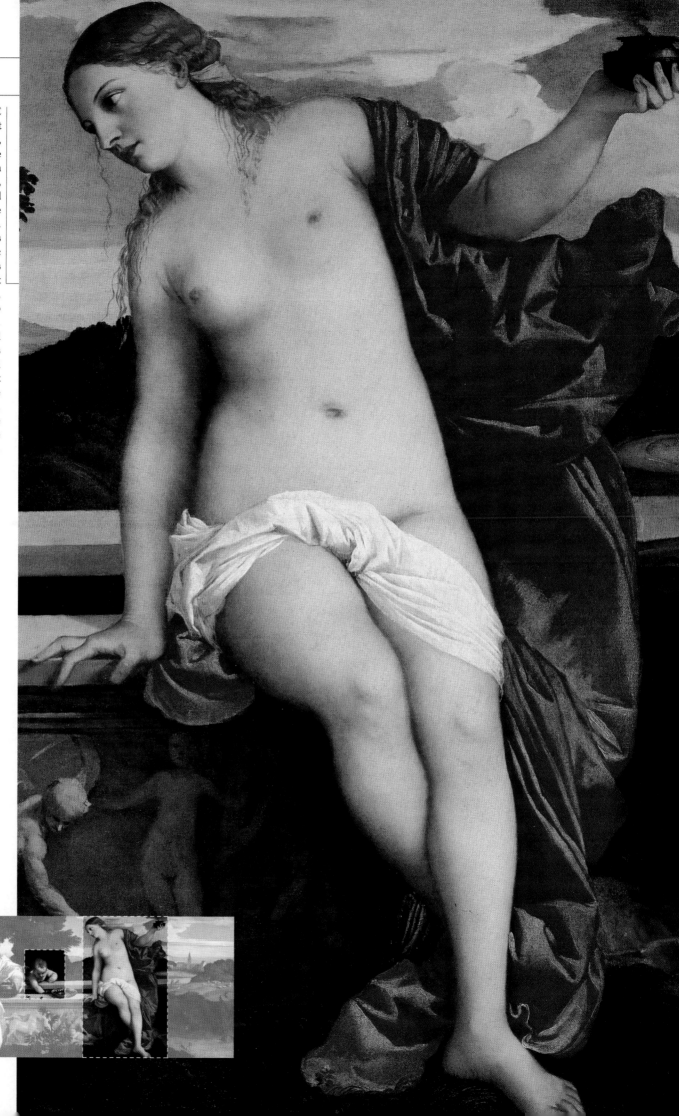

♦ SACRED LOVE

According to the most recent exegesis, the image of the nude woman, evoked in all her carnal splendor, is the symbol of the highest degree of love, intellectual love. Her nudity would thus not have an erotic charge, but alludes to the fact that heavenly beauty, to be admired, has no need of ornament. The burning lamp held in the nude Venus's hand, outstretched in her attempt to persuade the dressed figure, would symbolize the flame of divine love.

♦ TEMPERANCE

The little Cupid in the center of the sarcophagus, depicted in the act of plunging his hand into the water, plays an important role in the iconography of the painting. Not only is he the intermediary between the two kinds of love, but he is also the one who tempers the water, that is, he brings about a reconciliation of the dissension between chaste and sensual love. The problem was a component of Venetian culture and was treated by Pietro Bembo in his *Asolani*.

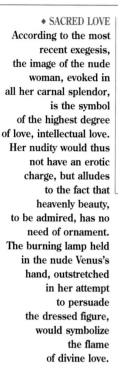

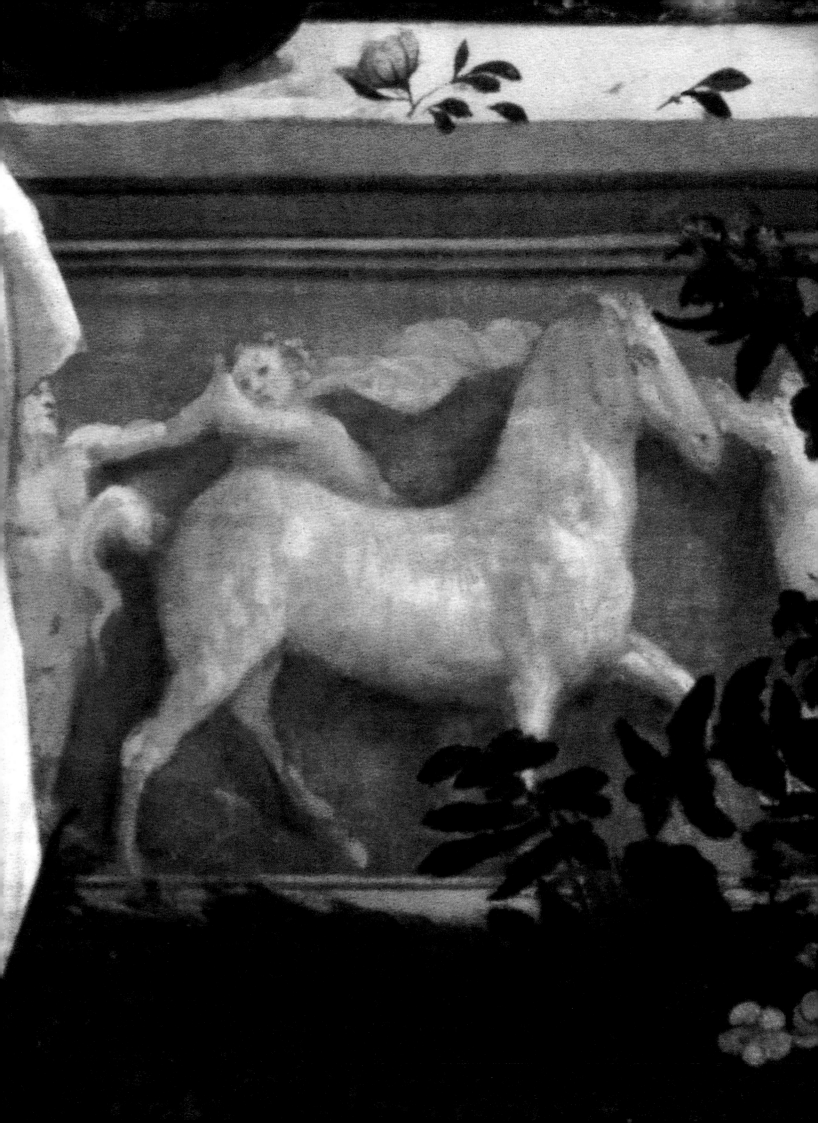

♦THE SARCOPHAGUS
The iconography of *Sacred and Profane Love* has often been linked with the famous romance by Francesco Colonna, *Hypnerotomachia Poliphili*, published in Venice by Aldus Manutius in 1499. In the work, which describes the amorous adventures of Polia and Polyphilus, one of the most important passages has to do with the sarcophagus of Adonis. The one pictured in the woodcut below, which is an illustration for the book, is very similar to the one in Titian's painting.

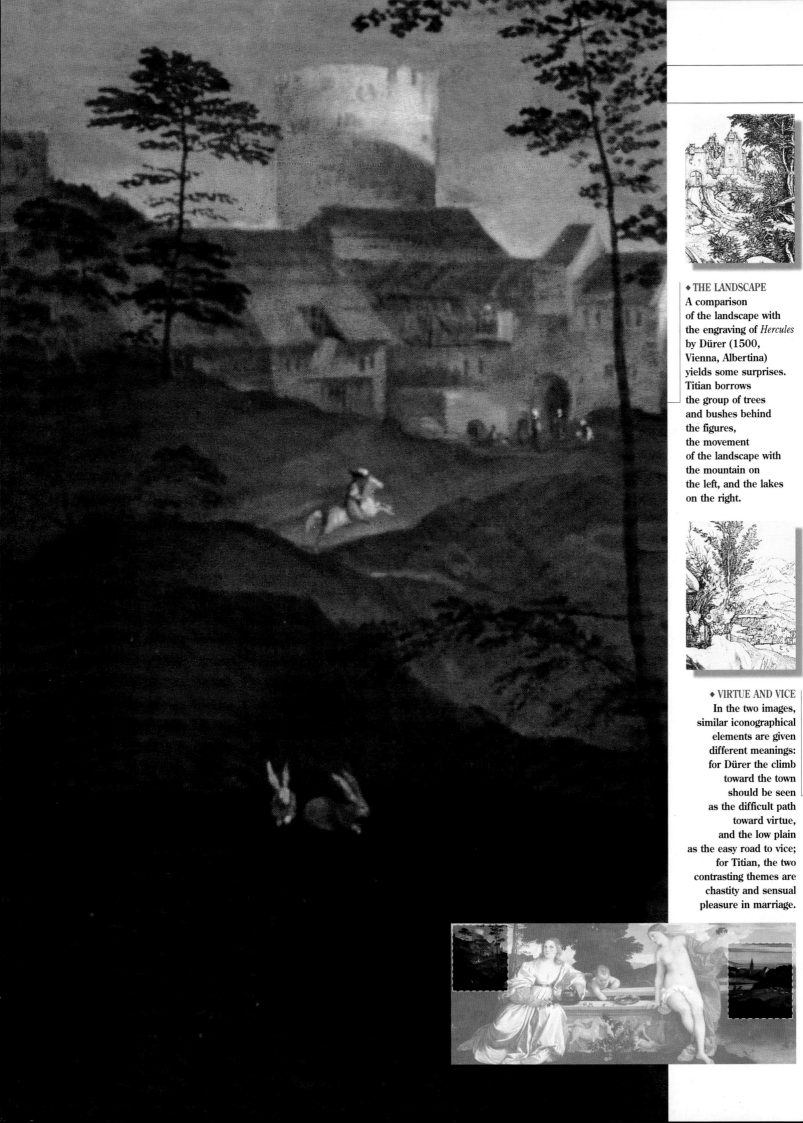

◆ THE LANDSCAPE
A comparison
of the landscape with
the engraving of *Hercules*
by Dürer (1500,
Vienna, Albertina)
yields some surprises.
Titian borrows
the group of trees
and bushes behind
the figures,
the movement
of the landscape with
the mountain on
the left, and the lakes
on the right.

◆ VIRTUE AND VICE
In the two images,
similar iconographical
elements are given
different meanings:
for Dürer the climb
toward the town
should be seen
as the difficult path
toward virtue,
and the low plain
as the easy road to vice;
for Titian, the two
contrasting themes are
chastity and sensual
pleasure in marriage.

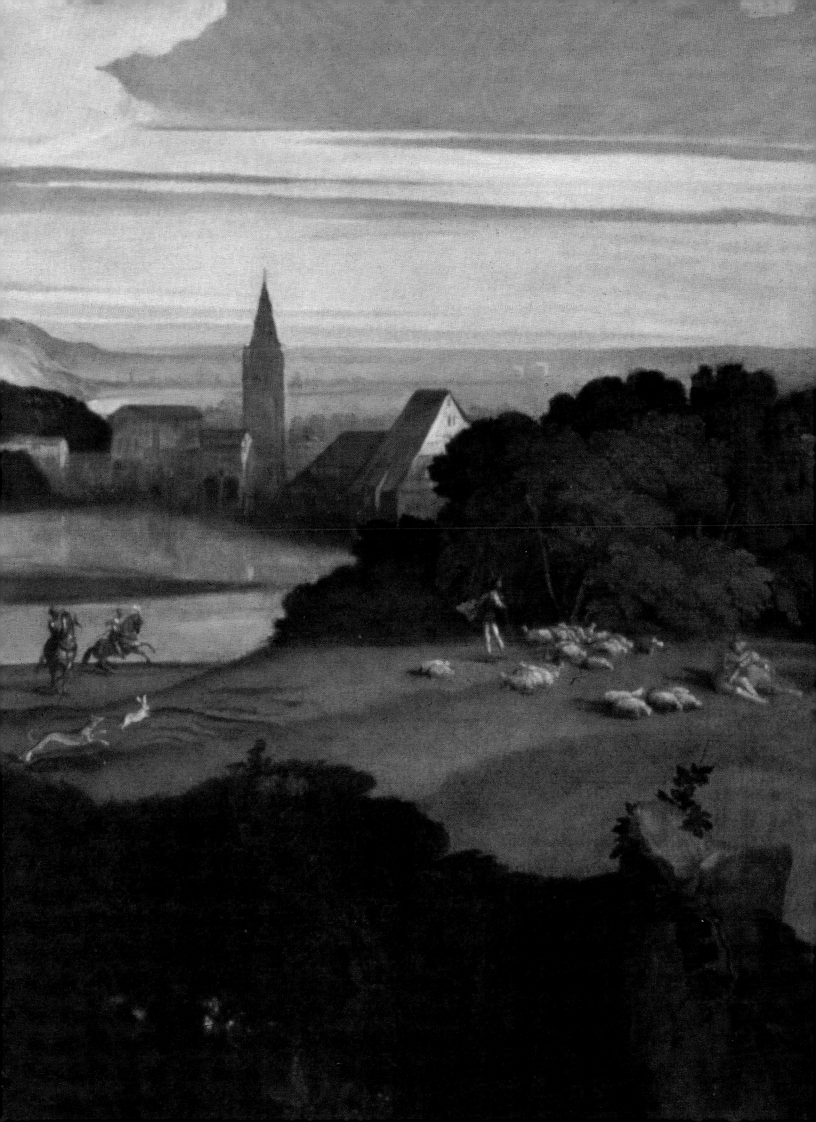

A TRADITION OF ILLUSTRIOUS SECRETS

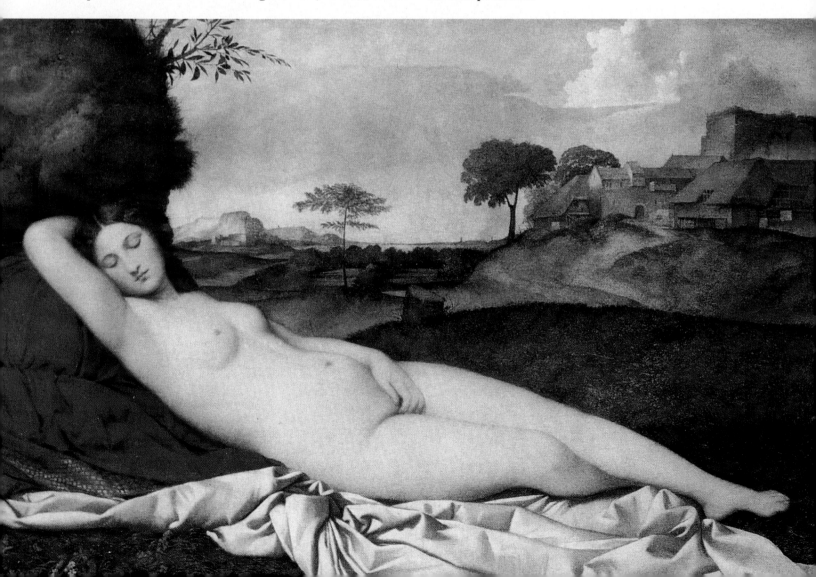

Illustrious examples of paintings whose interpretation is uncertain are frequent in painting tradition. Besides Giorgione's *Tempest*, doubts also surround the exegesis of his *Sleeping Venus* – usually attributed to Giorgione but in all probability painted by the young Titian around 1510-11. It is a subject that we often find in prints of the time, but it was certainly commissioned by an important patron at the suggestion of a man of letters.

● Caravaggio's *Bacchus*, with his fruit and glass of wine, must have a precise meaning which escapes us, and the same is true of still lifes, which are not simple descriptions of fruit or flowers or game but, at least until a certain point in history (around 1630), have an emblematic or allegorical meaning, which returns sometimes even later with sexual connotations; some seventeenth century paintings which we interpret as genre scenes, when read in the appropriate way reveal quite bold erotic details.

● In Spanish painting, conversely, still lifes often take on profound religious significance: for example the paintings by Juan van der Hamen y León (1596-1631) should be read as allegories of sin and redemption or as personifications of the Virgin Mary, and require reference to precise sacred and literary sources for interpretation.

♦ CARAVAGGIO
Bacchus
(c. 1596-97,
Florence, Uffizi).
The picture is an allusion
to the bridegroom in the
Song of Solomon. The myth
of Bacchus who died and
was resurrected was in
fact read by the
Neoplatonists as a
mysterious foreshadowing
of the Resurrection of
Christ.

♦ GIORGIONE
The Tempest
(Venice, Gallerie
dell'Accademia).
This is by antonomasia
the most mysterious
work in the history
of art. The extreme
sensitivity to nature and
color manifested here
becomes the essential
element of the
representation.

♦ GIORGIONE
Sleeping Venus
(1510, Dresden,
Gemäldegalerie).
The nude goddess
recumbent in a
landscape is an idea of
Giorgione's which Titian,
who finished the work
after his master's death,
would take up again
in numerous other
paintings.

♦ ALLEGORY OF TIME
GOVERNED BY
PRUDENCE
(1565, London,
National Gallery).
The allegory of Time,
below, is depicted
in the three ages of man.
The face on the left
is that of the artist,
while the other two are
portraits of his sons.

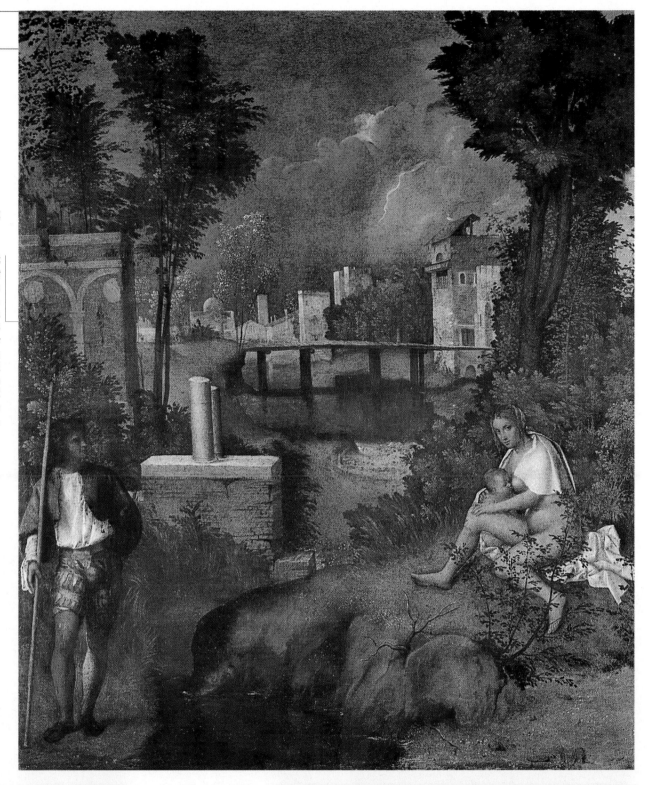

♦ JUAN VAN DER HAMEN
Y LEÓN
*Still Life with Glasses,
Pottery, and Sweets*
(1622, Madrid, Prado).
Here the allegorical
meanings
are expressed
by details
like the flies
on the decanter
and the ripe fruit.
Van der Hamen
is one of the most
interesting Spanish
genre painters.

CLASSICISM AND COLOR

Sacred and Profane Love belongs to Titian's early period, when, still under the influence of his master Giorgione as well as that of certain aspects of the work of Giovanni Bellini, he was acquiring his own language, which would later render his style unmistakable. It would become a point of reference for other Venetian painters even of the front rank, like Palma the Elder, Giovanni Busi called Cariani, and others.

● The painting is usually dated around 1515, in a moment when the artist's style is characterized by the perfect fusion of color and the human figure with the landscape. Painted in the same period are the *Noli me tangere* and *The Baptism of Christ*, where the element of color and tone is dominant, and of memorable portraits like *La Schiavona*, which still shows signs of Giorgione's lessons. Another painting with which *Sacred and Profane Love* shows close analogies, in typology as well, is *Flora* in the Uffizi. It too is one of the most significant examples of "coloristic classicism," the expression of a perfect ideal and formal balance, achieved using color as the principle of stylistic unity.

◆ PORTRAIT OF A LADY (LA SCHIAVONA)

(1510-12, London, National Gallery). Titian borrows from Giorgione the compositional solution of a close-up view of the figure shown in half-length. Note on the right the marble slab with the sitter's profile.

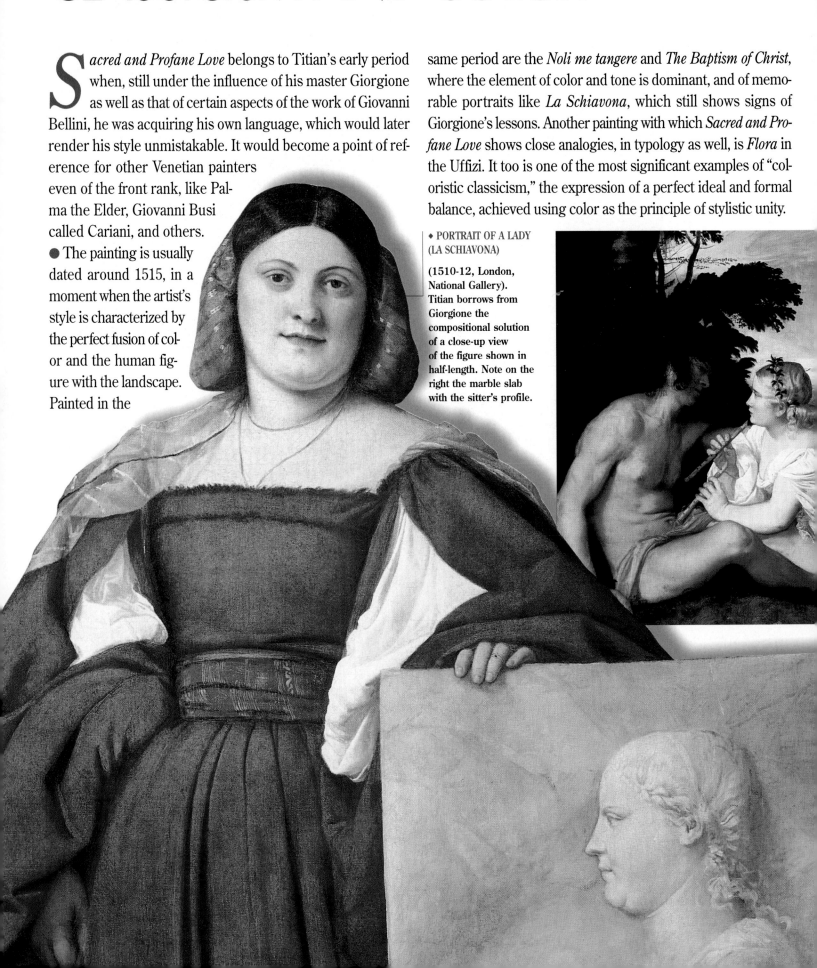

♦ ALLEGORY OF THE THREE AGES OF MAN (1513-15, Edinburgh, National Gallery of Scotland). The openly paratactic composition of the scene and its strongly allegorical content bring this picture close to *Sacred and Profane Love*. Its moral significance, evidenced by the pair of lovers and the old man in the middle ground meditating on death, is interpreted with Titian's happy and exquisite sense of color.

♦ THE OUTDOOR CONCERT (1511, Paris, Louvre). The theme of music in a landscape had already appeared in Venetian painting with this canvas, variously attributed to Giorgione and Titian. The work contains an evident allusion to musical harmony, represented by the woman playing the flute in concert with the young man on the lute, interrupted by the shepherd on the right.

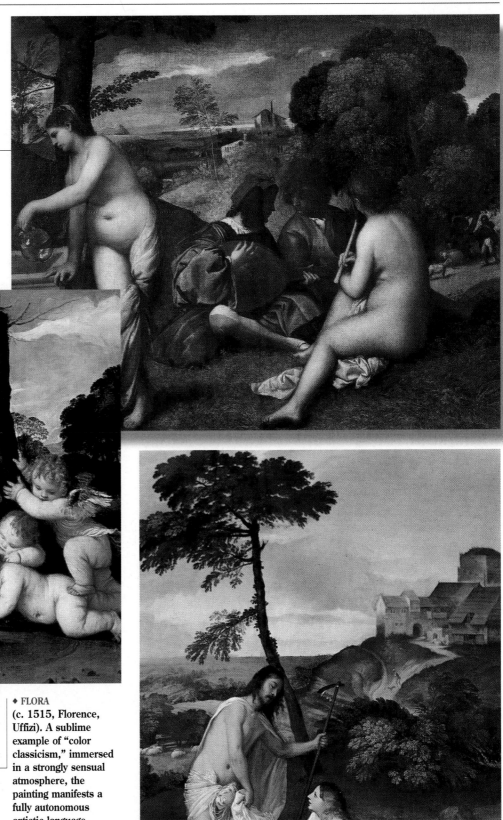

♦ FLORA (c. 1515, Florence, Uffizi). A sublime example of "color classicism," immersed in a strongly sensual atmosphere, the painting manifests a fully autonomous artistic language.

♦ NOLI ME TANGERE (c. 1512, London, National Gallery). In this painting, variously attributed to Giorgione and to Titian, the religious theme is inserted into the rich colorism of the landscape.

PATRONAGE AND AUTONOMY

The extreme difficulty encountered in interpreting Titian's painting is also due to the patron's request. In all probability, the theme was presented to the painter in consultation with a poet or man of letters who suggested the iconography. The idea of the artist's autonomy starts with Michelangelo, but it does not become reality until much later. We must not forget that in the sixteenth century, in the middle of the Italian Renaissance, even important painters were considered only able craftsmen: well-paid, to be sure, but without that independence which could permit them to turn down work that today might even be considered degrading.

● Thus, just as Leonardo at the court of Ludovico il Moro had to create models and designs for the costumes for ballets and charades, so too under Pope Innocent VIII or Sixtus IV did artists like Antoniazzo Romano or Piermatteo d'Amelia make designs for costumes and parades. It is also well known that famous artists painted parade shields or coats of arms to be placed over the outer entrance to public buildings, or were even required to paint and decorate furniture. All this ephemeral production is known from written sources or receipts for payment, but very few examples survive. Among them are the parade shield with the image of *David* by Andrea del Castagno (c. 1451, Washington, National Gallery of Art) and the coat of arms painted by the 14th century Sienese painter Taddeo di Bartolo. Even Masaccio himself left us one of his masterpieces in the so-called *Birth Salver*, a tray offered to new mothers after the birth of their child.

● Only Michelangelo, in the case of the tomb for Julius II, was able to abandon a job despite the fact that his patron was a pope. With him the idea begins to take shape of independence and of aesthetic autonomy, which would be reinforced in the course of the nineteenth century with Goya and the Impressionists and would lead to the situation of the twentieth century, when the artist is no longer bound by considerations of patronage.

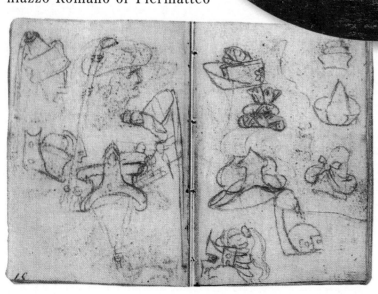

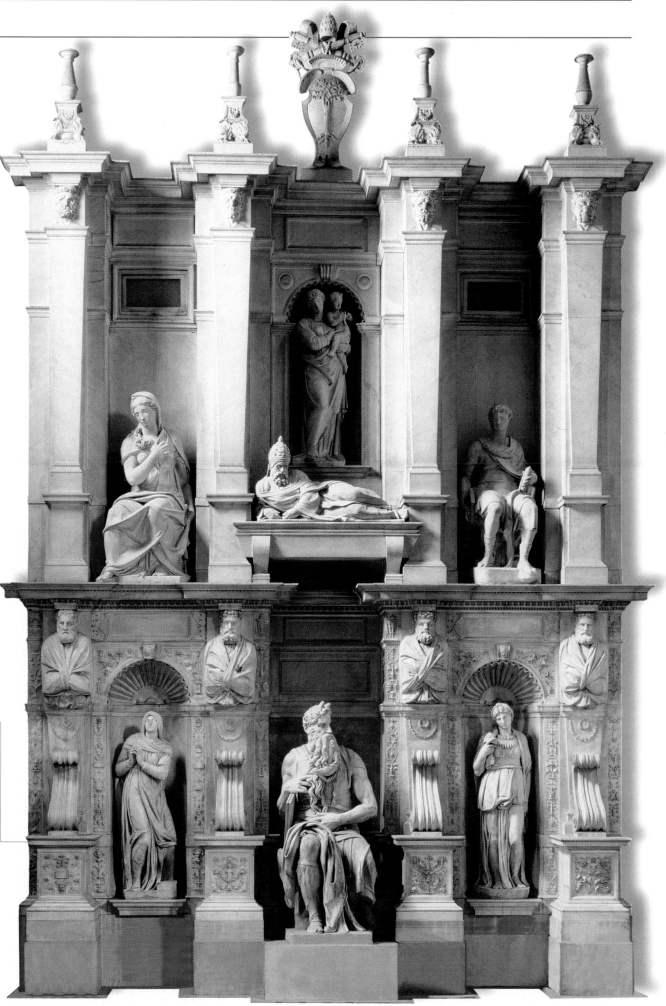

◆ LEONARDO
Studies of figures and a horse. Study of a woman dancing
(c. 1515, Venice, Gallerie dell'Accademia)
Leonardo's drawings reveal how his services were in demand even for the lesser needs of Ludovico il Moro's court. In particular in the *Foster Codex III* (c. 1494, below), which he used as a miscellaneous notebook, are found sketches for hats, ribbons, and other articles of dress for masquerades and festivities.

◆ MASACCIO
Birth Salver – Nativity
(1426-27, Berlin, Staatliche Museen).
The scene represents the procession of ladies and musicians bringing gifts to the woman who has just given birth (on the right of the painting).
The work, which on the back has the image of a young child scolding a puppy, has been placed by Longhi close to a period when the artist was refining his studies of perspective.

◆ MICHELANGELO
Tomb of Julius II
(1545, Rome, San Pietro in Vincoli).
With Julius II's commission to Michelangelo to design his tomb, we have the first instance of an artist's rebellion against papal patronage.
The work, assigned to the artist in 1505 and conceived to rise magnificently in Saint Peter's, was actually constructed in 1545 on a reduced design in the church of San Pietro in Vincoli.

BACCHANALS

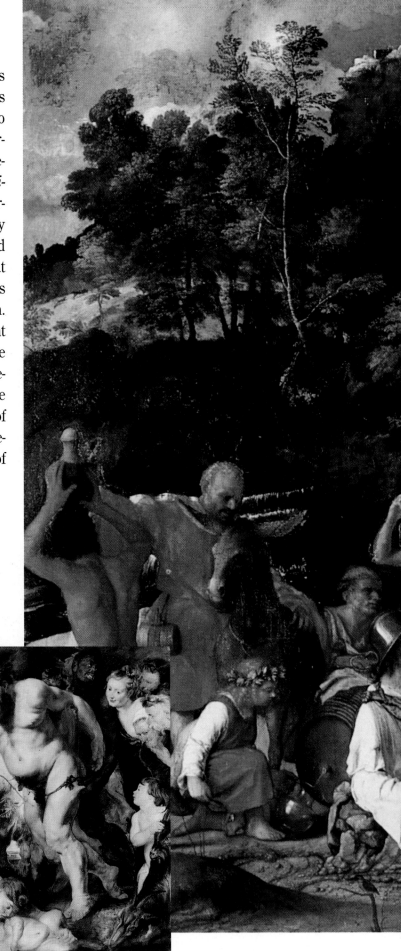

The most famous series of paintings manifesting Titian's adherence to the poetics of classicism is dedicated to his famous *Bacchanals*. Executed between 1519 and 1524 to decorate the "alabaster chamber" of Alfonso d'Este in Ferrara, a room that no longer exists, they represent respectively *The Worship of Venus*, *The Andrians*, and *Bacchus and Ariadne*. In 1598 the works were transferred to Rome by the Cardinal Legate Aldobrandini, and in 1639, through the viceroy Monterey, *The Worship of Venus* and *The Andrians* were donated to Felipe IV of Spain. *Bacchus and Ariadne* went to Great Britain at the beginning of the nineteenth century, where it was purchased for the collection of the National Gallery in London.

● The paintings all belong to the period in Titian's development called "coloristic classicism;" their subjects all reveal the same dependence on literary and mythological sources, which is reworked through Renaissance culture, and in style they show the same adherence to a figurative language based on variations of tone and color. *The Worship of Venus*, executed for Alfonso between 1518 and 1519, corresponds to the description of one of the paintings devoted to the followers of Eros, found in the sixth book of the *Images* by Philostratus. In *The Andrians* (1518-1519) the subject is taken from another passage of the same text, in which Dionysus arrives by sea on the island of Andros, where the inhabitants await him in a drunken state. The last work in the series, *Bacchus and Ariadne* (1522-1523), whose iconographical source is found in Ovid and Catullus, represents the meeting between Ariadne and Bacchus with his train.

◆ PIETER PAUL RUBENS
The Drunken Silenus
(c. 1618-20, Munich, Alte Pinakothek). The representation of this theme corresponds to the lively interest of Rubens, the supreme interpreter of Baroque culture, in Venetian Renaissance painting and Titian in particular.

● The heritage left by Titian's *Bacchanals* was considerable, especially in the seventeenth century: famous artists like Pietro da Cortona, Pieter Paul Rubens, and Nicolas Poussin would take up not only the iconographical motif, but also the warm and chromatically intense tonality which distinguishes the master's works.

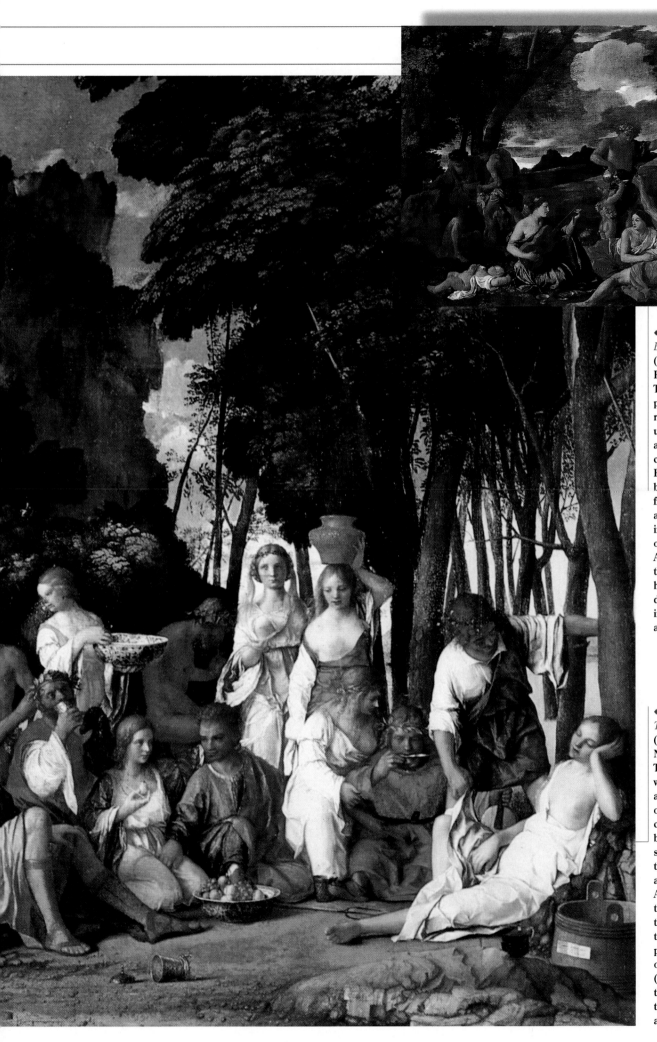

♦ NICOLAS POUSSIN
Bacchanal with Lute
(c. 1631-33,
Paris, Louvre).
The great French
painter (1594-1665)
reworks the theme
using classicizing forms
and the warm, sensual
colors of Titian.
He could have
borrowed them directly
from Titian's paintings,
at that point transferred
into the collection
of the Cardinal Legate
Aldobrandini from
the Este court, which
he was able to view
during his long stay
in Rome, where he
arrived around 1624.

♦ GIOVANNI BELLINI
The Feast of the Gods
(1514, Washington,
National Gallery of Art).
This signed and dated
work is the first in
a series of pictures
on similar themes,
commissioned
by Alfonso d'Este from
several artists, among
them Raphael
and Fra' Bartolomeo.
After their death,
the duke transferred
the commission
to Titian, who repainted
part of the landscape
of this picture
(c. 1529), altering
the mountain view on
the left and the foliage
at upper right.

21

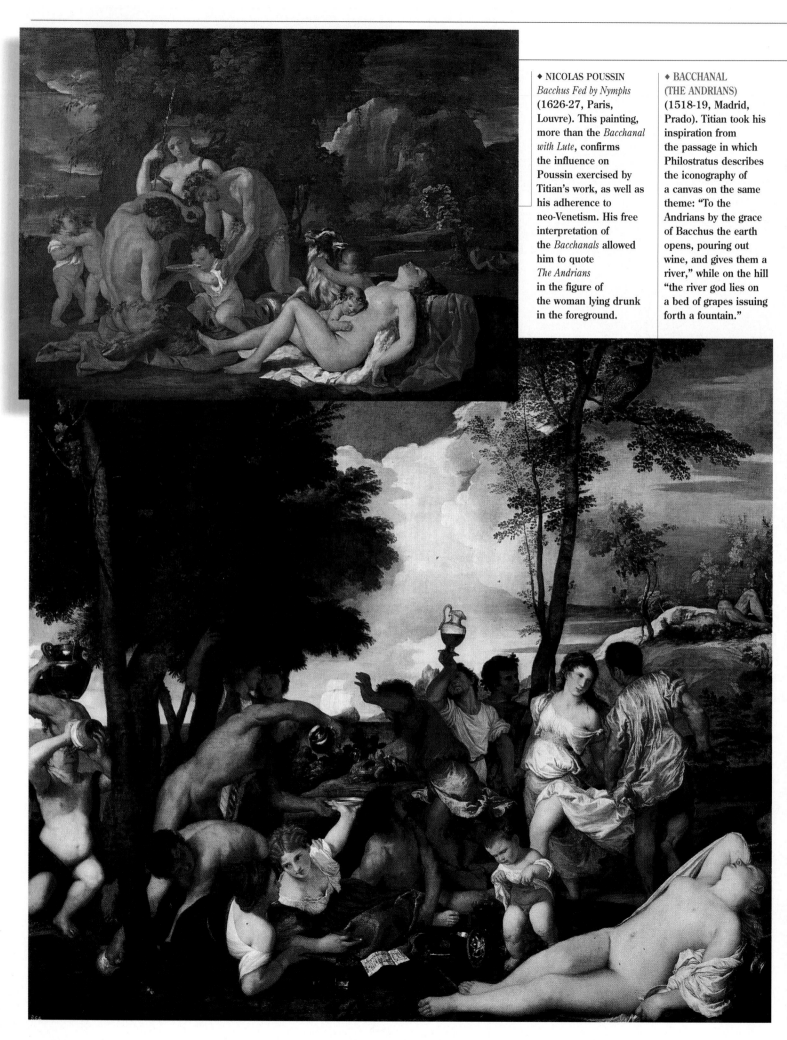

♦ NICOLAS POUSSIN
Bacchus Fed by Nymphs
(1626-27, Paris,
Louvre). This painting,
more than the *Bacchanal
with Lute*, confirms
the influence on
Poussin exercised by
Titian's work, as well as
his adherence to
neo-Venetism. His free
interpretation of
the *Bacchanals* allowed
him to quote
The Andrians
in the figure of
the woman lying drunk
in the foreground.

♦ BACCHANAL
(THE ANDRIANS)
(1518-19, Madrid,
Prado). Titian took his
inspiration from
the passage in which
Philostratus describes
the iconography of
a canvas on the same
theme: "To the
Andrians by the grace
of Bacchus the earth
opens, pouring out
wine, and gives them a
river," while on the hill
"the river god lies on
a bed of grapes issuing
forth a fountain."

◆ THE WORSHIP
OF VENUS
(1518-19,
Madrid, Prado).
It seems it was Duke
Alfonso d'Este
who wanted Titian's
first painting for his
alabaster chamber
to take its subject from
the *Images* of
Philostratus the Elder.
His choice is
documented by a thick
correspondence
between him and the
painter, who stated
in a letter dated April 1,
1518 that he could not
think of a more
pleasant subject or one
closer to his heart.

◆ ANTON VAN DICK
The Triumph of Silenus
(1618-19, London,
National Gallery).
The painting reproposes
the theme already used
by Rubens for his
picture now in Munich.
The younger Flemish
artist shows his attempt
to compete with
the master,
accentuating
the dramatic tone
of the lively
composition,
painted with a dense
pasty brush.

◆ PIETRO DA CORTONA
The Triumph of Bacchus
(c. 1623, Rome,
Capitoline Museums).
The artist is the leading
interpreter of the
seventeenth-century neo-
Venetian movement and
the principal exponent
of Italian Baroque art
(1596-1669). This work
manifests his full
adherence to the coloristic,
sensual art of Titian.

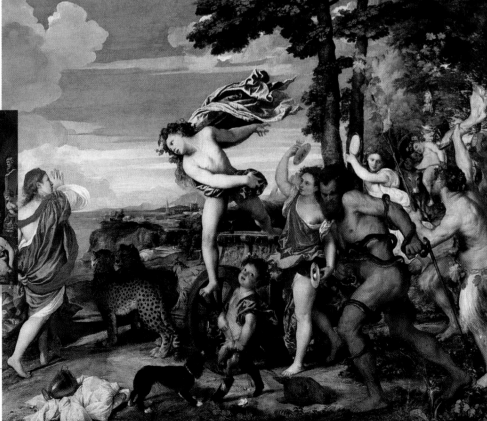

◆ BACCHUS AND
ARIADNE
(1522-23, London,
National Gallery).
The third painting made
for the duke is perhaps
the highest achievement
of Titian's classicism.
The subject, too,
expresses more than the
others the achievement
of a rediscovered
relationship between
man and nature:
it represents the meeting
between Bacchus,
returning victorious from
India, and Ariadne,
abandoned by Theseus
on the island of Naxos.

TECHNIQUE IN THE LIGHT OF NEW INVESTIGATIONS

♦ THE DRESS
Infrared digital reflectoscopy revealed that the bodice of the woman's dress was originally high-necked.

Sacred and Profane Love has recently been freed of the old yellowed varnish which had dimmed its chromatic balance and made it seem practically monochrome. The colors had altered considerably, especially in the area of the vegetation, executed with a copper-based green paint that had darkened with age. Besides relining the canvas and reattaching the paint layers to their support, the restorers aimed essentially at recreating, as much as possible, the original harmonies of color.

● Thanks to new methods of non-invasive investigation, the restoration brought out interesting information about Titian's technique in the early phase of his career. Essentially, he would sketch with charcoal the figures or basic elements of the scene and then create the overall composition directly with his paintbrush. In the work under examination here, Titian painted the vegetation and background directly on top of the primer, while the gray dress worn by *Profane Love* and *Sacred Love's* red-colored cloak were painted on the green ground.

This technique, which practically eliminates underdrawing, is accompanied by the completely unprecedented manner of spreading the pigment in three different layers (base, intensification or lightening, highlights or polish), a method perfectly suited to Titian's tonal colorism.

● Through the diagnostic procedures to which the painting has been subjected, it was possible to highlight the artist's *pentimenti*, visible mainly in the figure of the woman on the left. Stratigraphic analysis of the paint brought out the fact that the first application for the dress was made with red paint and that only later did the artist decide to cover it with gray, thus changing the painting's meaning substantially. Other *pentimenti* concern the probable presence of another seated female figure and of more luxuriant vegetation made up of flowers and leaves of every sort.

♦ THE PENTIMENTI
The image to the right shows the X-ray, made in forty frames, of *Sacred and Profane Love*. This method of analysis of the painting, along with infrared digital reflectoscopy, made it possible to see first of all the underdrawing and secondly the artist's *pentimenti*, highlighted by the graphic elaboration of the painting (above). Titian seems to have worked longer and with greater complexity on the left side of the composition. In fact, the figures to the left and right of *Profane Love* and the rich drapery have been covered by white lead and vermilion.

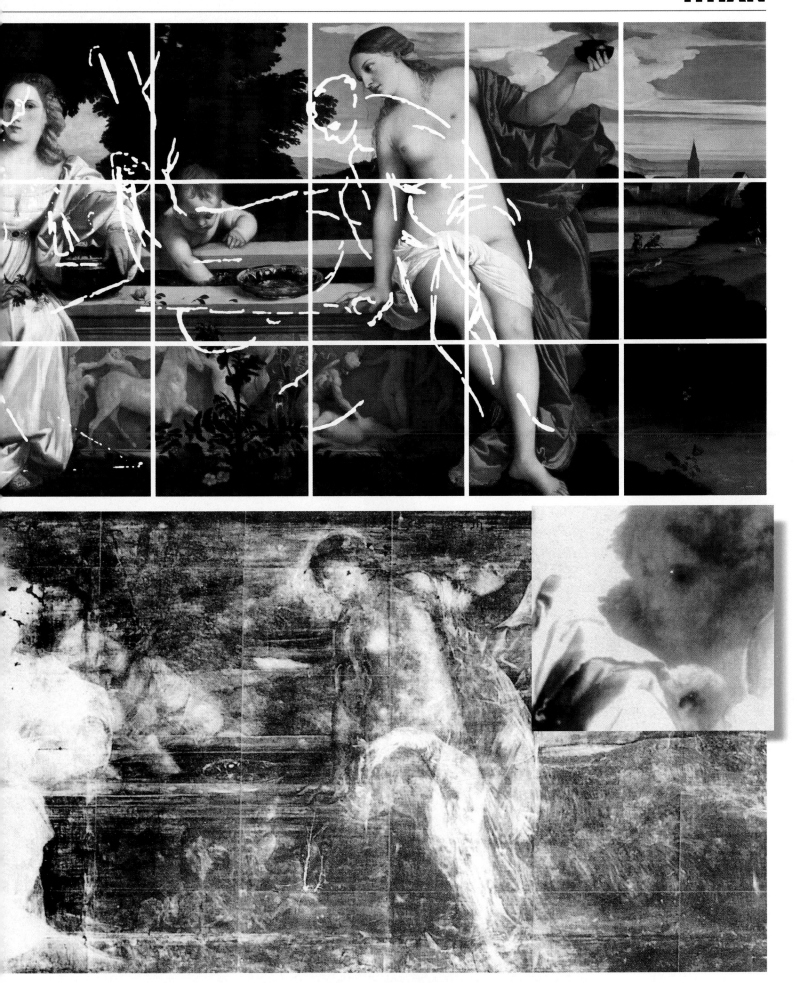

HISTORICAL IDENTITY

◆ SELF-PORTRAIT
(c. 1567, Madrid, Prado).
Painted when the master
was in his 80s,
it expresses
his psychological state.

Titian's portrait production represents one of the most important parts of his activities, not only because it makes up a consistent group – about one hundred paintings – but also because it reflects developments in his style over the course of his long career. Painted during the same stylistic phase as *Sacred and Profane Love* are the so-called portrait of *Ariosto*, probably executed between 1508 and 1511, and *La Schiavona*, in which the warmly human sensuality of the artist's youthful period melds with an overall sense of psychological profundity and takes form in a treatment of the figure in perspective, framed by parapets, a scheme derived from Giorgione.

● From the 1520s onwards, not only does his stylistic approach to the sitter change, now represented full length and strengthened both formally and coloristically, but also the artist's patrons are of a different sort, now important personages in the Renaissance courts of Italy and all of Europe. Titian would draw from this new, intense relationship his typology of the official portrait, highlighting not only the sitter's psychological attitude but above all his or her historical and political identity.

● This is the case with the portraits painted by Titian for King Charles V of Spain, which efficaciously interpret the two sides of the emperor: from the almost private representation of *Charles V and his Dog* to the historical and celebratory aspect of *Charles V on Horseback*. After the 1540s Titian painted majestically beautiful portraits (*Pietro Aretino, Jacopo Strada*) in which he accentuates his psychological investigation of the sitter.

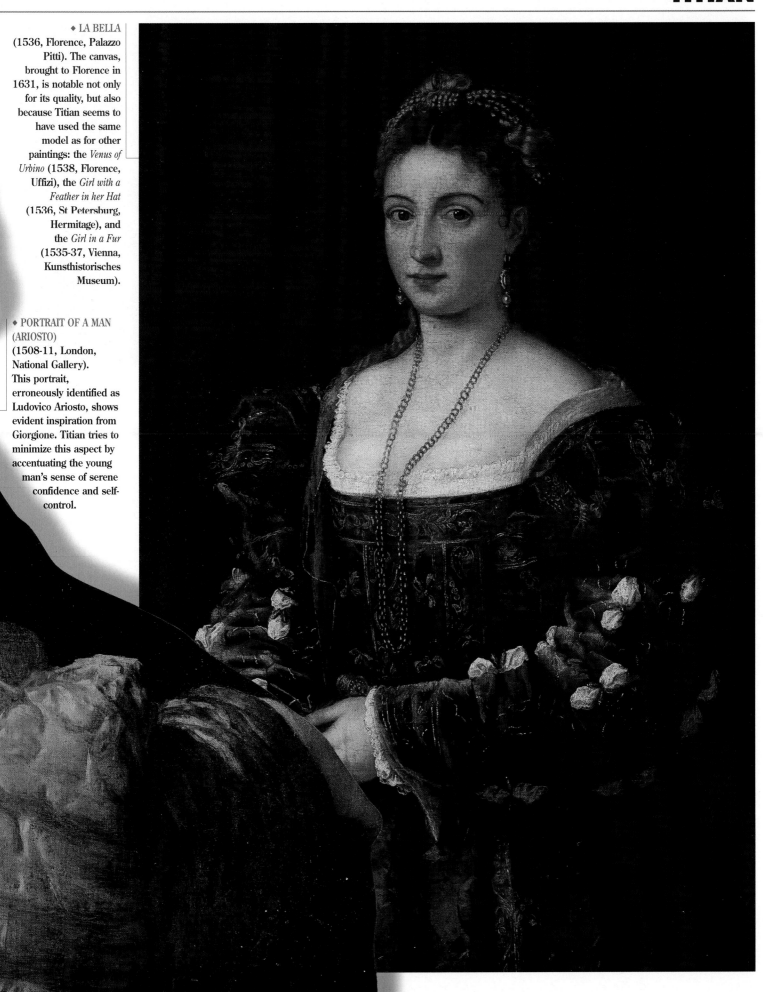

◆ LA BELLA
(1536, Florence, Palazzo
Pitti). The canvas,
brought to Florence in
1631, is notable not only
for its quality, but also
because Titian seems to
have used the same
model as for other
paintings: the *Venus of
Urbino* (1538, Florence,
Uffizi), the *Girl with a
Feather in her Hat*
(1536, St Petersburg,
Hermitage), and
the *Girl in a Fur*
(1535-37, Vienna,
Kunsthistorisches
Museum).

◆ PORTRAIT OF A MAN
(ARIOSTO)
(1508-11, London,
National Gallery).
This portrait,
erroneously identified as
Ludovico Ariosto, shows
evident inspiration from
Giorgione. Titian tries to
minimize this aspect by
accentuating the young
man's sense of serene
confidence and self-
control.

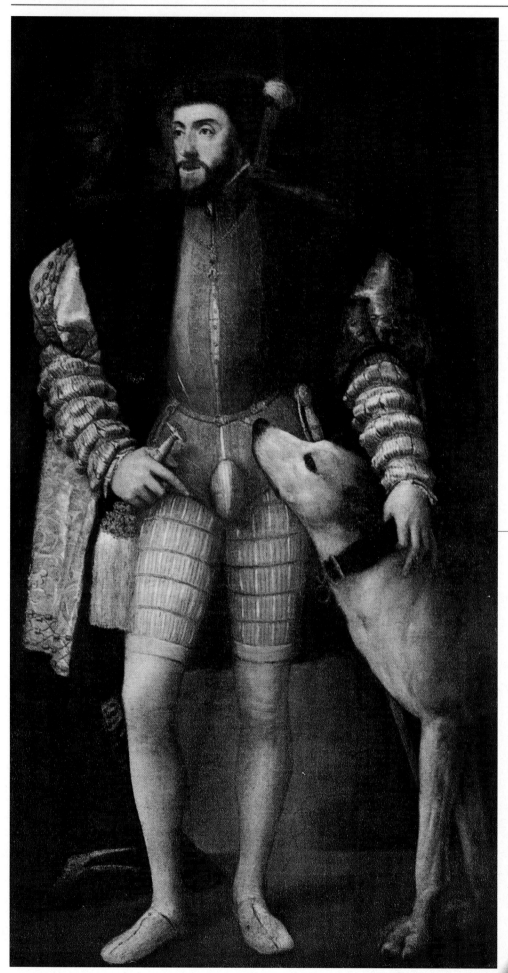

♦ PORTRAIT OF
CHARLES V
(1532-33,
Madrid, Prado).
Probably painted during
the emperor's stay
in Bologna,
this is one of Titian's
earliest portraits
of Charles V.
Compared to other
portraits of his
illustrious sitter,
this one is surprising
in its generic
expressiveness and
the use of a traditional
cliché, evident also
in the full-length pose.

♦ PORTRAIT OF A MAN
(THE YOUNG
ENGLISHMAN)
(1540-45, Florence,
Palazzo Pitti). It has not
been possible to trace
the sitter's identity. The
monumentality, heroic
stance, and dense
brushstroke seem to
confirm a date for the
picture between 1540
and 1545.

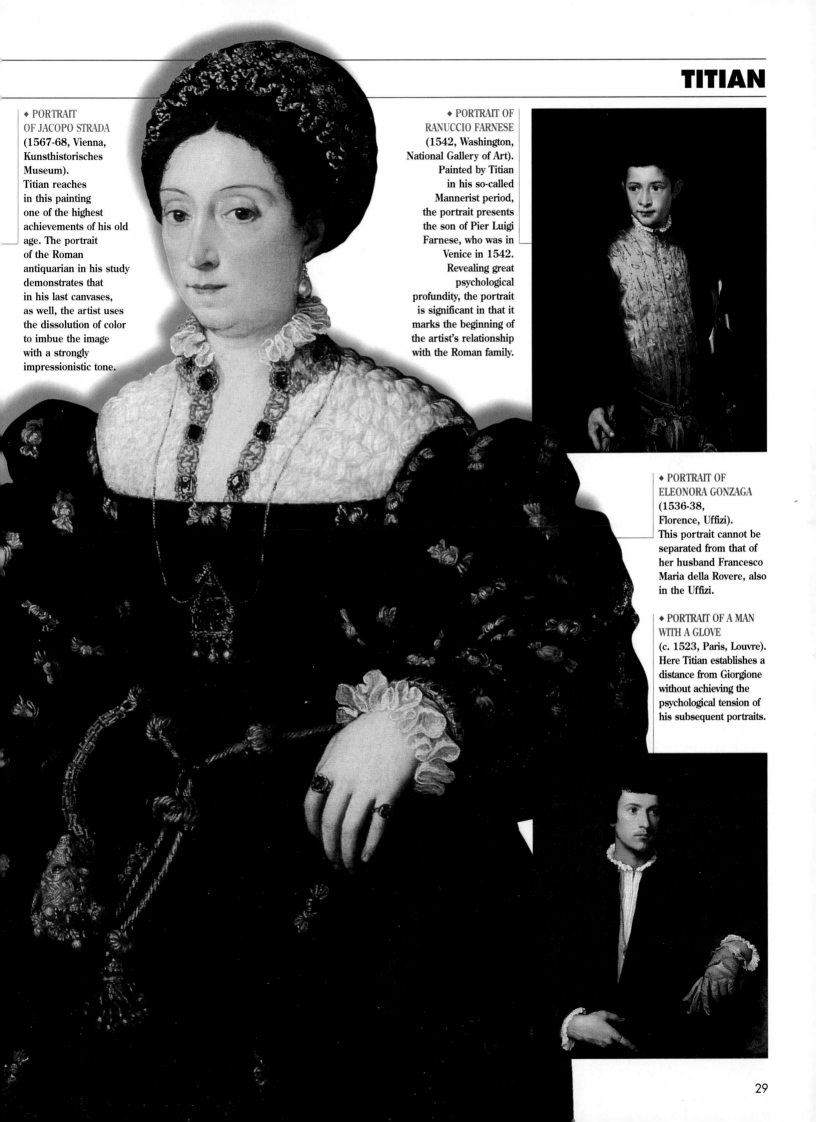

◆ PORTRAIT
OF JACOPO STRADA
(1567-68, Vienna,
Kunsthistorisches
Museum).
Titian reaches
in this painting
one of the highest
achievements of his old
age. The portrait
of the Roman
antiquarian in his study
demonstrates that
in his last canvases,
as well, the artist uses
the dissolution of color
to imbue the image
with a strongly
impressionistic tone.

◆ PORTRAIT OF
RANUCCIO FARNESE
(1542, Washington,
National Gallery of Art).
Painted by Titian
in his so-called
Mannerist period,
the portrait presents
the son of Pier Luigi
Farnese, who was in
Venice in 1542.
Revealing great
psychological
profundity, the portrait
is significant in that it
marks the beginning of
the artist's relationship
with the Roman family.

◆ PORTRAIT OF
ELEONORA GONZAGA
(1536-38,
Florence, Uffizi).
This portrait cannot be
separated from that of
her husband Francesco
Maria della Rovere, also
in the Uffizi.

◆ PORTRAIT OF A MAN
WITH A GLOVE
(c. 1523, Paris, Louvre).
Here Titian establishes a
distance from Giorgione
without achieving the
psychological tension of
his subsequent portraits.

PATRICIAN PATRONAGE

The commission for *Sacred and Profane Love* from the prominent Venetian Aurelio family around 1515 is evidence of the fact that Titian, from the very beginning of his career, could count on the favor of important personalities and institutions in Venetian public life. One of his first patrons of this sort* was Jacopo Pesaro, who commissioned the painting of St Peter, Pope Alexander VI, and himself to commemorate the role he played in the battle of 1502, in which the Venetians won the island of Santa Maura back from the Turks. The other great work painted by Titian for the Pesaro family is a *Sacra Conversazione* (called the *Pesaro Altarpiece*), installed in the prestigious church of the Frari on the condition that the family contribute every year to the cost of preparations for the Feast of the Immaculate Conception. Noteworthy in this painting, besides the extraordinary new concept of space, is the particular emphasis placed on the figure of the donor.

The young Titian's other prestigious work, the *Assumption of the Virgin* commissioned by the prior of the convent, Father Germano da Casale, was already in the Dominican church.

● Another important example of Titian's ability to gain the support of illustrious patrons is the *Averoldi Polyptych*. The painting was made in 1520-22 for the papal Legate Altobello Averoldi, and is now in the church of Santi Nazzaro e Celso in Brescia. The work was acclaimed as so beautiful that, even though it followed a model by that point obsolete, the fifteenth century polyptych, it became the object of attention from Duke Alfonso d'Este, who tried to buy it.

● The votive portrait of the Vendramin family, finally, reaffirms, around the end of the 1540s, Titian's interest in the representation of the Venetian aristocracy, conscious of its role of supremacy and power.

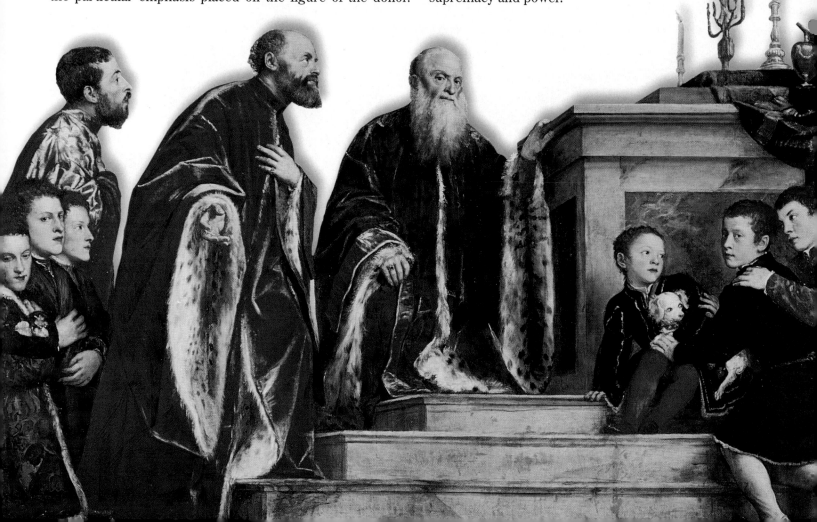

♦ SACRA CONVERSAZIONE WITH THE PESARO DONORS (THE PESARO ALTARPIECE)
(1519-26, Venice, Santa Maria Gloriosa dei Frari). The painting (see the oval on facing page) was commissioned from Titian for a side altar in the church of the Frari.

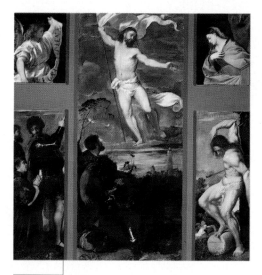

♦ THE AVEROLDI POLYPTYCH
(1522, Brescia, church of Santi Nazzaro and Celso). Titian manages to impart unity to the complex through a dynamic use of light, particularly in the effects of backlighting in the central panel showing the scene of the Resurrection.

♦ ST PETER, ALEXANDER VI AND BISHOP PESARO
(1503-07, Antwerp, Musée Royal des Beaux-Arts). This is one of the first paintings made by Titian for an illustrious patron. It was probably painted between 1503 and 1507.

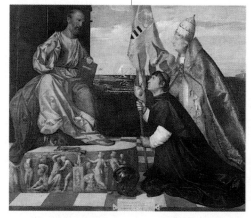

♦ VOTIVE PORTRAIT OF THE VENDRAMIN FAMILY
(1543-47, London, National Gallery). Three generations of the family are represented in the act of adoring the reliquary of the True Cross. Especially beautiful is the portrait of the little boy with his dog.

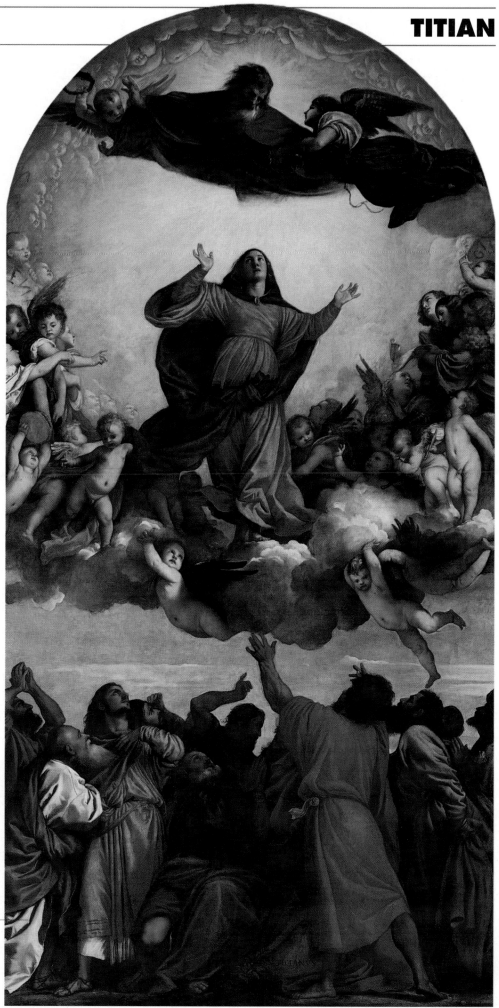

♦ THE ASSUMPTION OF THE VIRGIN
(1516-18, Venice, Santa Maria Gloriosa dei Frari). The large altarpiece confirmed Titian's artistic supremacy in Venice. It aroused contrasting reactions: the people were enthusiastic, the patrons perplexed.

THE PAINTER OF THE POWERFUL

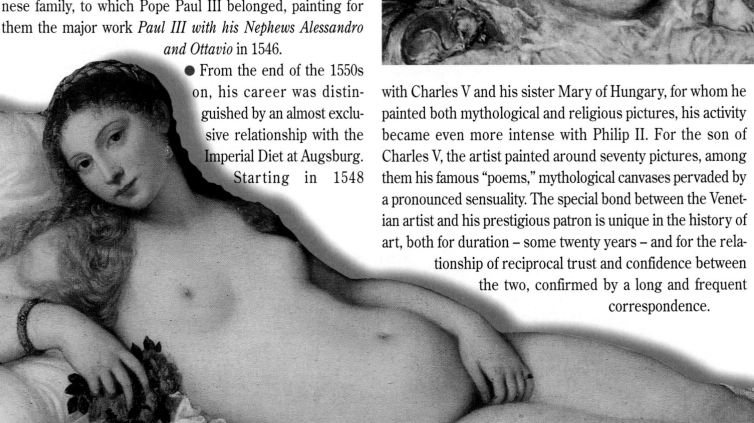

During his long life, Titian was an astute administrator of his image as an artist and succeeded in obtaining for himself the most important patronage of the century. From the second decade of the sixteenth century onwards, his work was known not only within the sphere of Venetian society, but was in demand also by the major Renaissance courts. This is the case with the already mentioned *Bacchanals*, painted for Alfonso d'Este, duke of Ferrara, who put him into contact with Federico Gonzaga, duke of Mantua, who in turn introduced him to the emperor Charles V and to Francesco Maria della Rovere, duke of Urbino. Already an established portraitist of important figures, in the 1540s he received the patronage of the Farnese family, to which Pope Paul III belonged, painting for them the major work *Paul III with his Nephews Alessandro and Ottavio* in 1546.

● From the end of the 1550s on, his career was distinguished by an almost exclusive relationship with the Imperial Diet at Augsburg. Starting in 1548 with Charles V and his sister Mary of Hungary, for whom he painted both mythological and religious pictures, his activity became even more intense with Philip II. For the son of Charles V, the artist painted around seventy pictures, among them his famous "poems," mythological canvases pervaded by a pronounced sensuality. The special bond between the Venetian artist and his prestigious patron is unique in the history of art, both for duration – some twenty years – and for the relationship of reciprocal trust and confidence between the two, confirmed by a long and frequent correspondence.

♦ DANAE
(1553-54,
Madrid, Prado).
The representation of
Danae is characterized,
in comparison with
the one in Naples,
by intense bright colors,
a dense pasty pigment,
and the presence
of the servant in place
of Cupid.

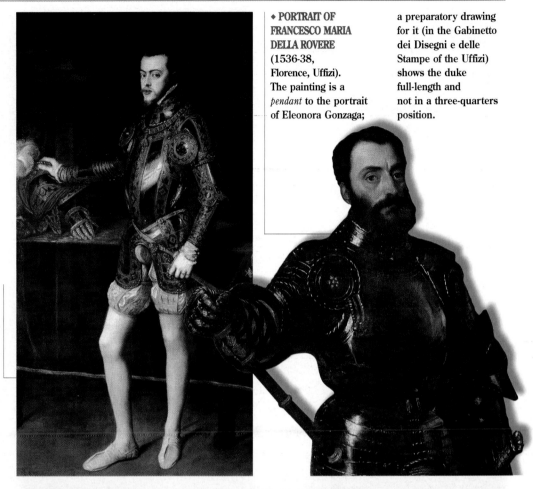

♦ PORTRAIT
OF PHILIP II
(1551, Madrid, Prado).
Painted by Titian during
his second stay in
Augsburg, in February
of 1551, the painting
represents the
sovereign, not yet king
of Spain, wearing the
armor that is still
preserved in the
armory of the Royal
Palace in Madrid.

♦ PORTRAIT OF
FRANCESCO MARIA
DELLA ROVERE
(1536-38,
Florence, Uffizi).
The painting is a
pendant to the portrait
of Eleonora Gonzaga;
a preparatory drawing
for it (in the Gabinetto
dei Disegni e delle
Stampe of the Uffizi)
shows the duke
full-length and
not in a three-quarters
position.

♦ THE VENUS OF
URBINO
(1538, Florence,
Uffizi). The iconography
of the reclining Venus
here undergoes a
precise evolution.
The goddess has lost all
contact with nature,
evident in Giorgione's
interpretation, assuming
an air of intimate
sensuality that is
echoed also in the
setting: an interior,
where the dog is a
symbol of domestic
fidelity.

♦ VENUS AND ADONIS
(1553, Madrid, Prado).
The theme of Venus's
farewell to Adonis,
inspired by Ovid's
Metamorphoses, appears in
the series of paintings
commissioned from
Titian by Philip II and
called "poems."
The artist justified to his
patron the position of the
goddess with her back
turned to the view, citing
reasons of the picture's
placement in the room,
facing a Venus "seen
from the front."

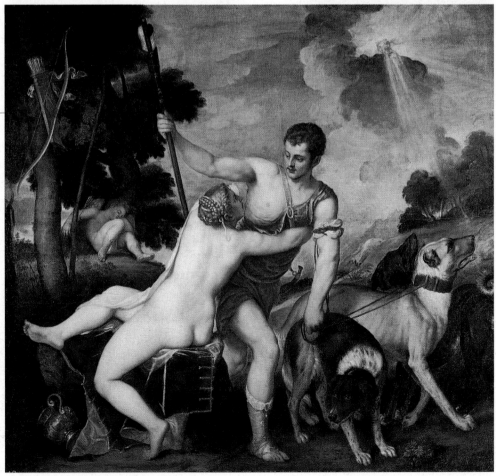

LEAVING NATURALISM BEHIND

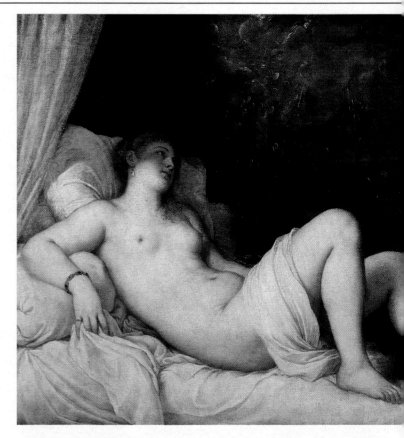

At the end of the 1530s Titian's style changed radically, moving away from an application of the paint in compact areas to a more rapid brushstroke, soaked in light. This change, which marks his definitive move away from illusionistic naturalism, was probably accentuated by the presence in Venice between 1539 and 1541 of the Tuscan Mannerist painters Francesco Salviati and Giorgio Vasari and by a generic interest in Michelangelo. It cannot be a coincidence that within the year 1544 Titian was summoned to paint three Bible scenes for the ceiling of Santo Spirito in Isola (now in Santa Maria della Salute), originally commissioned from Vasari in 1541. Although the paintings were actually executed by Titian's workshop, the artist certainly conceived and designed them, and his adherence to the new experience of Mannerism is evident and undeniable.

● The work which undoubtedly manifests the painter's adherence to Mannerist themes is *Christ Crowned with Thorns* (1542-44), painted for the church of Santa Maria delle Grazie in Milan and now in the Louvre. The emphasis on the powerful musculature and torsion of the executioners' bodies, clearly derived from classical statuary, is combined with intense light effects and a deliberate chiasmus in the structure of the scene. Titian's Mannerist phase, however, ran its course within a few years, coming to an end with the artist's stay in Rome (1545-46), where he was called by Alessandro Farnese. Already evident in the *Danae*, now in Capodimonte in Naples, is his interest in fluid forms shaped by color, characteristic of his next style.

◆ **CHRIST CROWNED WITH THORNS** (1542-44, Paris, Louvre). In the body of the tortured Christ reference is clear to classical sculpture and the bust of Laocoon.

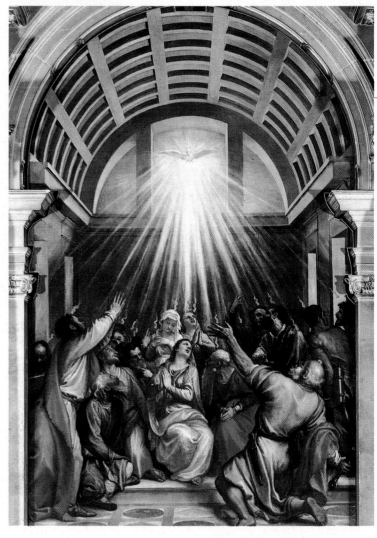

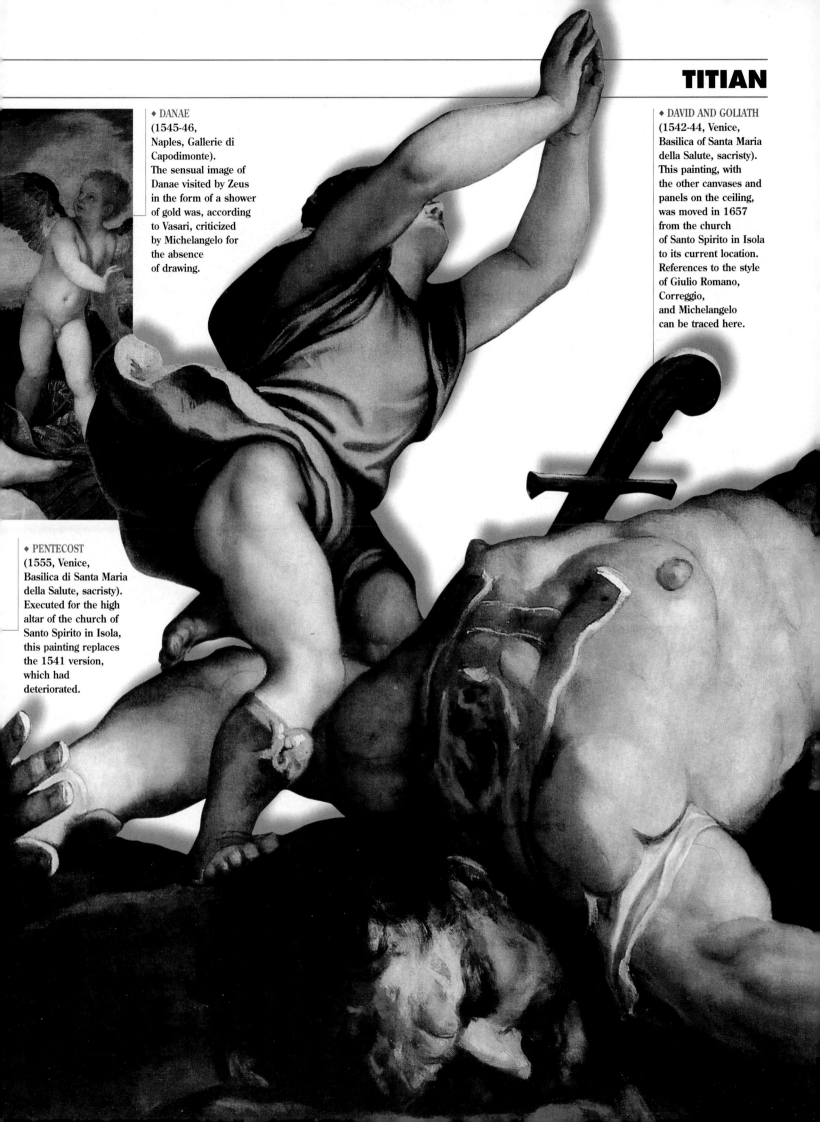

♦ DANAE
(1545-46,
Naples, Gallerie di
Capodimonte).
The sensual image of
Danae visited by Zeus
in the form of a shower
of gold was, according
to Vasari, criticized
by Michelangelo for
the absence
of drawing.

♦ DAVID AND GOLIATH
(1542-44, Venice,
Basilica of Santa Maria
della Salute, sacristy).
This painting, with
the other canvases and
panels on the ceiling,
was moved in 1657
from the church
of Santo Spirito in Isola
to its current location.
References to the style
of Giulio Romano,
Correggio,
and Michelangelo
can be traced here.

♦ PENTECOST
(1555, Venice,
Basilica di Santa Maria
della Salute, sacristy).
Executed for the high
altar of the church of
Santo Spirito in Isola,
this painting replaces
the 1541 version,
which had
deteriorated.

THE DISSOLUTION OF THE FORM

The last great phase of Titian's activity, characterized, as we have seen, by his close relationship with the court of Charles V and Philip II, is marked stylistically by an application of the pigment in thick, overlapping layers, by which the progressive dissolution of the form reaches its zenith, most dramatically expressed in works like *Christ Crowned with Thorns* (c. 1570, Munich, Bayerische Staatsgemäldesammlungen), *Tarquin and Lucretia* (c. 1570, Vienna, Akademie der bildenden Künste), and *The Punishment of Marsyas* (1575, Kromeriz National Museum).

● A comparison of the Munich *Crowning with Thorns* with the painting on the same subject in the Louvre, painted thirty years earlier, is emblematic of Titian's change in style. The practically identical iconographical conception is accompanied by a completely different stylistic interpretation: the compact for-

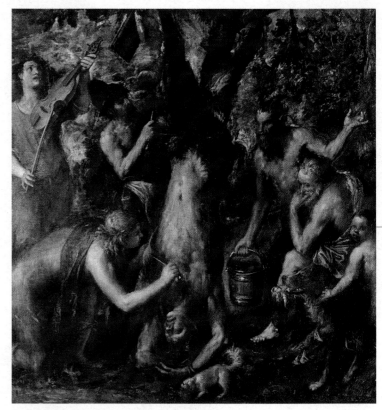

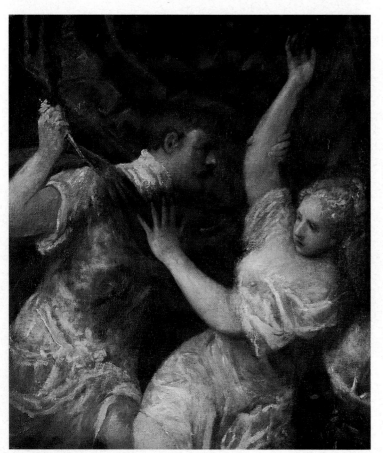

mal handling of the Michelangelesque figures in the painting in the Louvre is supplanted here by a dissolving color which melts the forms, yielding a heightened emotional intensity.

● A dramatically tragic view of existence undoubtedly underlies these last manifestations of style marking the work of the 1570s, culminating in the pessimism of *The Punishment of Marsyas*, which emphasizes the extreme cruelty of the subject in an expressionistic approach.

● Titian's last work, painted when the artist was ninety years old and completed by his student Jacopo Palma the Younger, is the *Pietà* currently in the Accademia in Venice. The subject, permeated by a strongly symbolic air and difficult to interpret, centers on the theme of death. Painted for his own tomb, the painting contains precise autobiographical references not only in the figure of Nicodemus, whose facial features are Titian's own, but also in the devotional picture inserted into the painting on the right, where Titian and his son Orazio pray to invoke the Virgin's deliverance from the plague. The drama of the subject is reinforced by the dissolution of the forms into clumps of paint, held together only by color.

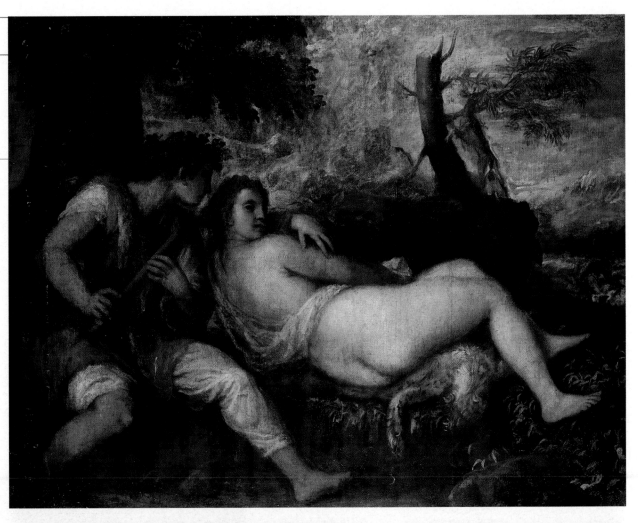

◆ NYMPH AND
SHEPHERD
(1570, Vienna,
Kunsthistorisches
Museum). In this work
from his old age, Titian
returns to the themes of
music and landscape
found in his early
activity, but in the
context of a completely
different style, now
marked by a brush
soaked in paint.

◆ THE PUNISHMENT OF
MARSYAS
(1570-76, Kromeriz,
National Museum).
The fable of Marsyas,
flayed alive for having
dared to challenge
Apollo, is recounted
with a strong tragic
sense and an awareness
of the cruel destiny
of mankind.

◆ THE ENTOMBMENT
(c. 1566,
Madrid, Prado).
The entire atmosphere
of the painting,
like the poses
of the figures,
exudes a strong
emotional tension
through the rarefied
use of color.

◆ THE CROWNING
WITH THORNS
(c. 1570, Munich,
Bayerische
Staatsgemälde-
sammlungen, upper
left). The figures are as
though pulled out of the
shadowy background by
the loose brushwork of
the late Titian.

◆ TARQUIN AND
LUCRETIA
(1570, Vienna,
Akademie der
bildenden Künste).
The dissolution of
the color accentuates
the drama of
the subject, of which
various replicas
were made.

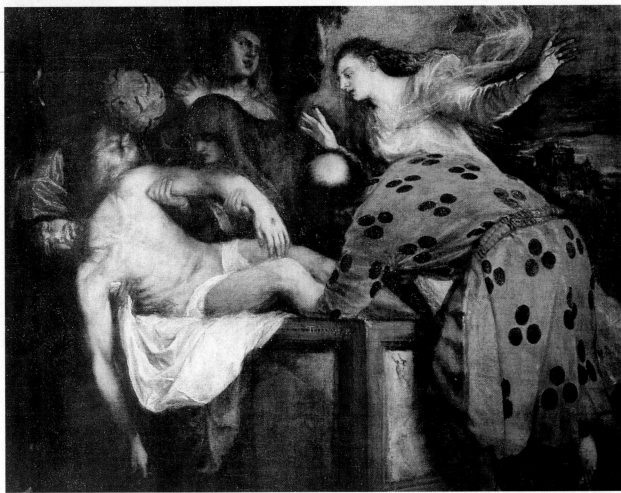

PRODUCTION: THE EPILOGUE

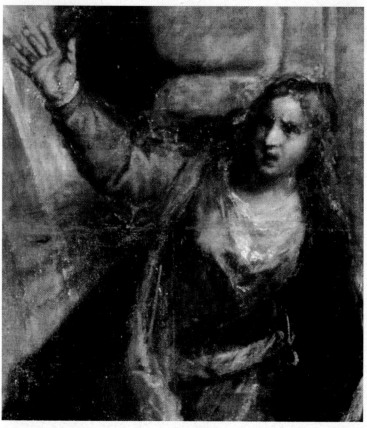

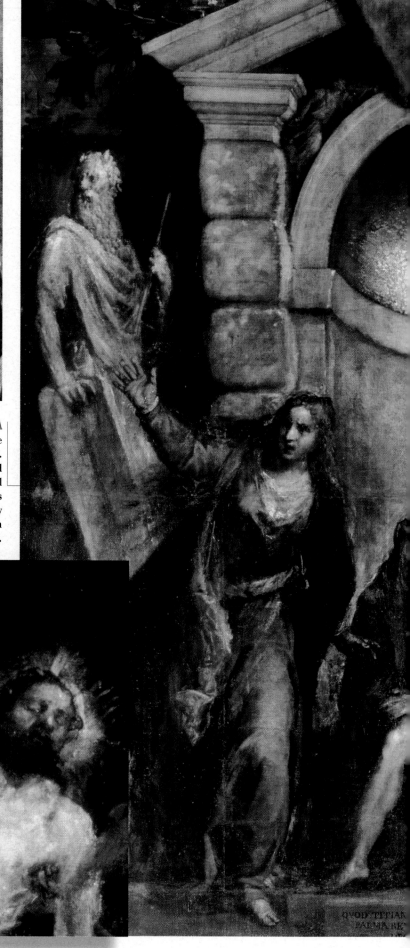

♦ A LAST LESSON
IN STYLE
Mary Magdalen's cry of
grief, accentuated by
the highly dramatic
gesture of her arm,
contrasts with the
immobile, tragic fixed
stare of the Virgin
holding up the lifeless
body of her son. The
intense expressionism
of the painting is
achieved through a
veritable chromatic
alchemy that destroys
and recomposes the
paint.

♦ THE PIETÀ
(1576, Venice, Gallerie
dell'Accademia).
This work is considered
Titian's spiritual
testament, revealing his
concentration now
on the theme of death
and Resurrection.

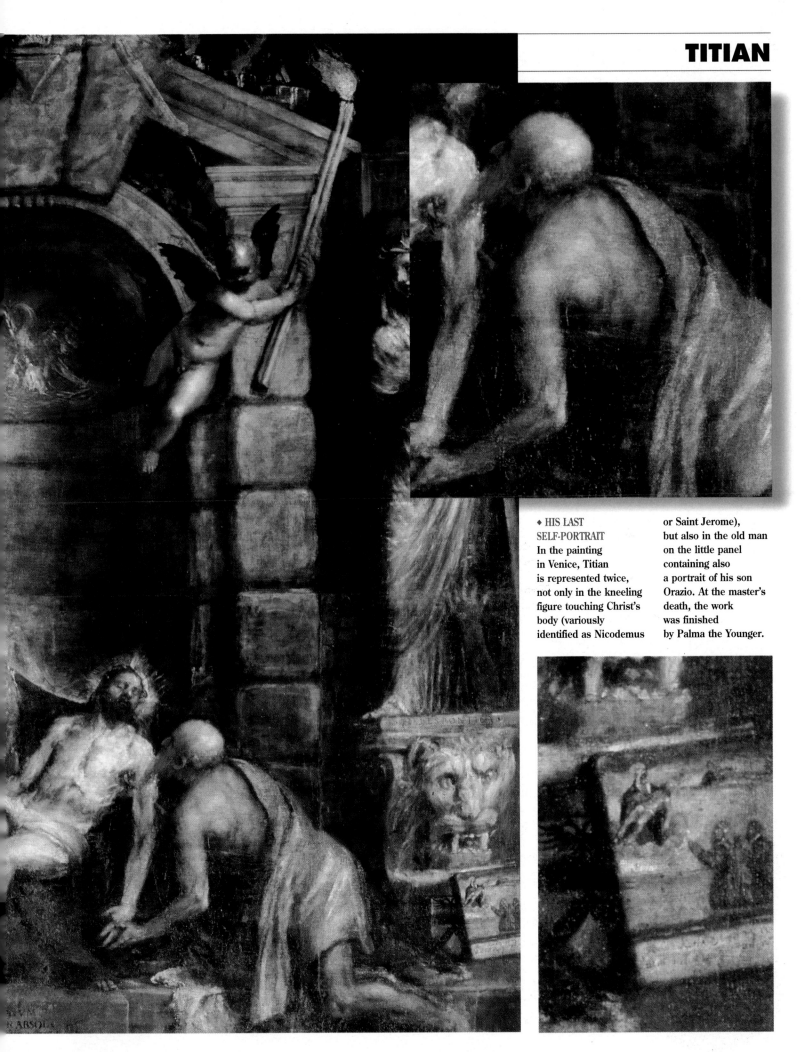

◆ HIS LAST
SELF-PORTRAIT
In the painting
in Venice, Titian
is represented twice,
not only in the kneeling
figure touching Christ's
body (variously
identified as Nicodemus
or Saint Jerome),
but also in the old man
on the little panel
containing also
a portrait of his son
Orazio. At the master's
death, the work
was finished
by Palma the Younger.

A LIFE COVERING A CENTURY

Titian's long artistic activity stretched over the first three-quarters of the sixteenth century and thus encompassed a period in which important historical and political events profoundly affected the destiny of Europe. One of Titian's earliest works is the altarpiece for Jacopo Pesaro, painted between 1503 and 1506 to commemorate the peace achieved between Venice and the Ottoman empire.

● With the death of Giorgione and Carpaccio in 1510 and of Giovanni Bellini in 1516, Titian became the only artistic personality to whom Venetian patrons could turn. The other great painter from the Venetian mainland, Lorenzo Lotto, did not work for Venetian society, but for patrons on the mainland and in other regions such as Lombardy and the Marches.

● During the papacies of Julius II (1503-13) and Leo X (1513-21), the great era began of papal patronage, with Michelangelo's vault for the Sistine Chapel (1508-12) and Raphael's *Stanze della Segnatura*, *dell'Incendio*, and *di Eliodoro* (1509-17).

● In 1517 the Protestant Reformation was inaugurated when Luther nailed his 95 theses to the door of Wittenberg Cathedral. The Catholic Church responded in 1520 by excommunicating Luther with the papal bull *Exsurge Domine*.

● Another drama shook Christianity in 1527 when Rome was sacked by the imperial troops of Charles V. Among the artists abandoning the papal city were Pietro Aretino and Jacopo Sansovino, who went to Venice.

● The papacy organized its forces against the spread of the Lutheran religion, founding in 1534

◆ SELF-PORTRAIT (Braunschweig, Herzog Anton Ulrich Museum). The painting (in the oval at left) probably presents the image of the mysterious painter from the Veneto area, Titian's teacher, whose face appears to emerge from an atmosphere of pensive gloom and melancholy. The artist seems willingly to sustain a true dialogue with the observer.

◆ VENETIAN ARTIST OF THE SIXTEENTH CENTURY *The Council of Trent* (16th century, Paris, Louvre). The painting represents the opening session of the Council of Trent in 1545.

◆ LUCAS CRANACH *Portrait of Luther* (1529, Florence, Uffizi). The sharp, clear contour line brings out the intense spirituality of the subject.

◆CHARLES V (1548, Munich, Bayerische Staatsgemäldesammlungen). The work was painted by Titian in Augsburg.

the Society of Jesus and opening, after various attempts, the Council of Trent in 1545. Between 1536 and 1541 Michelangelo frescoed the altar wall of the Sistine Chapel with *The Last Judgment*, while Titian came to Rome in 1545, summoned there by Paul III and the Farnese family.

● Titian's relationship with the Habsburgs was strengthened in 1548 when he went to Augsburg for the meeting of the Imperial Diet. After Charles V's abdication in 1555, the Spanish section of the Habsburg empire was entrusted to Philip II, who obtained with the treaty of Cateau Cambrésis (1559) the absolute dominion of Spain over Europe. The relationship between the emperor and Titian would last until the artist's death.

● In 1563 the Council of Trent drew to a close. It marked the final break with the Protestant world and established the general lines of Church reform. With the victory of the Holy Alliance in the battle of Lepanto in 1571, the foundation was laid for the beginning of the decline of the Ottoman imperial navy.

● In 1576, Titian died.

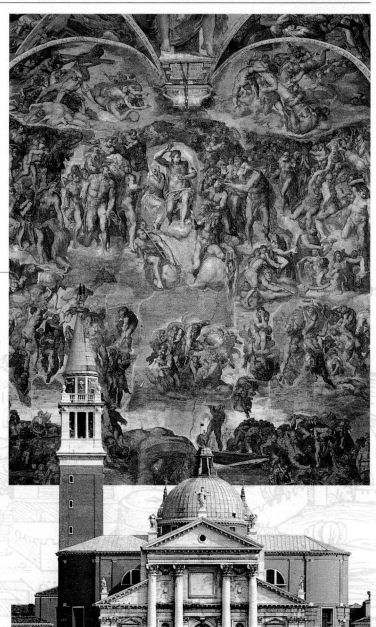

◆ MICHELANGELO
The Last Judgment
(1536-41, Rome, Sistine Chapel).
The work was commissioned by Paul III.

◆ PALLADIO
San Giorgio Maggiore
(c. 1566, Venice).
In this work, as in the church of the Redentore, highly original solutions are proposed.

◆ THE BATTLE OF LEPANTO
Artist of the Venetian school
(16th century, Greenwich, National Maritime Museum).
The last battle using galleys.

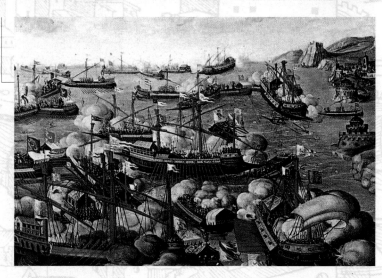

THE LEGACY OF TITIAN

COLORISM

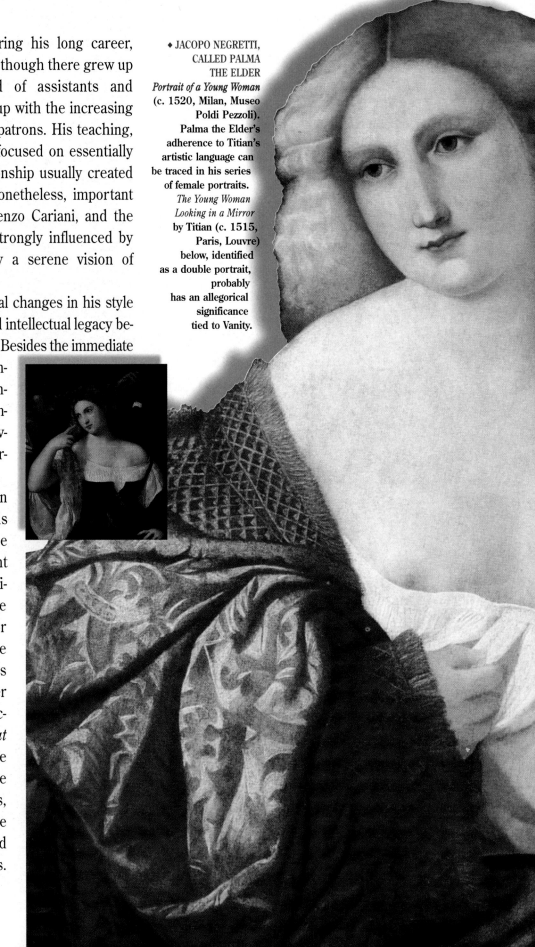

It cannot be said that Titian, during his long career, actually established a school, even though there grew up around him a veritable crowd of assistants and collaborators to permit him to keep up with the increasing demand for his work on the part of patrons. His teaching, Jacopo Palma the Younger tells us, focused on essentially technical aspects, without the relationship usually created beween a master and his pupils. Nonetheless, important painters like Palma the Elder, Vincenzo Cariani, and the early Sebastiano dal Piombo were strongly influenced by the artist's early work, marked by a serene vision of classicism.

● Titian's capacity to make substantial changes in his style would be fundamental to his moral and intellectual legacy being picked up by generations of artists. Besides the immediate reference to Titian on the part of contemporary Venetian painters like Tintoretto and Jacopo Bassano, his most important legacy concerns the entire seventeenth century and involves numerous artists of the most diverse origins.

● The Titian revival in the 1630s, in particular of the early Titian and his most famous works, that is to say the *Bacchanals*, gave rise to a movement of colorists, which contributed significantly to the definition of the Baroque as an artistic language based on color and movement. The artists who in one way or another used stylistic elements taken from the great Venetian painter are numberless. From Annibale Caracci's citation, in his *Samaritan Woman at the Well* in Vienna, of the landscape from *Sacred and Profane Love*, to the full forms of Rubens's female nudes, to Van Dyck's attention to portraiture and the feeling for a rich *impasto* and brilliant color of Velasquez or Rubens.

◆ JACOPO NEGRETTI, CALLED PALMA THE ELDER
Portrait of a Young Woman (c. 1520, Milan, Museo Poldi Pezzoli). Palma the Elder's adherence to Titian's artistic language can be traced in his series of female portraits. *The Young Woman Looking in a Mirror* by Titian (c. 1515, Paris, Louvre) below, identified as a double portrait, probably has an allegorical significance tied to Vanity.

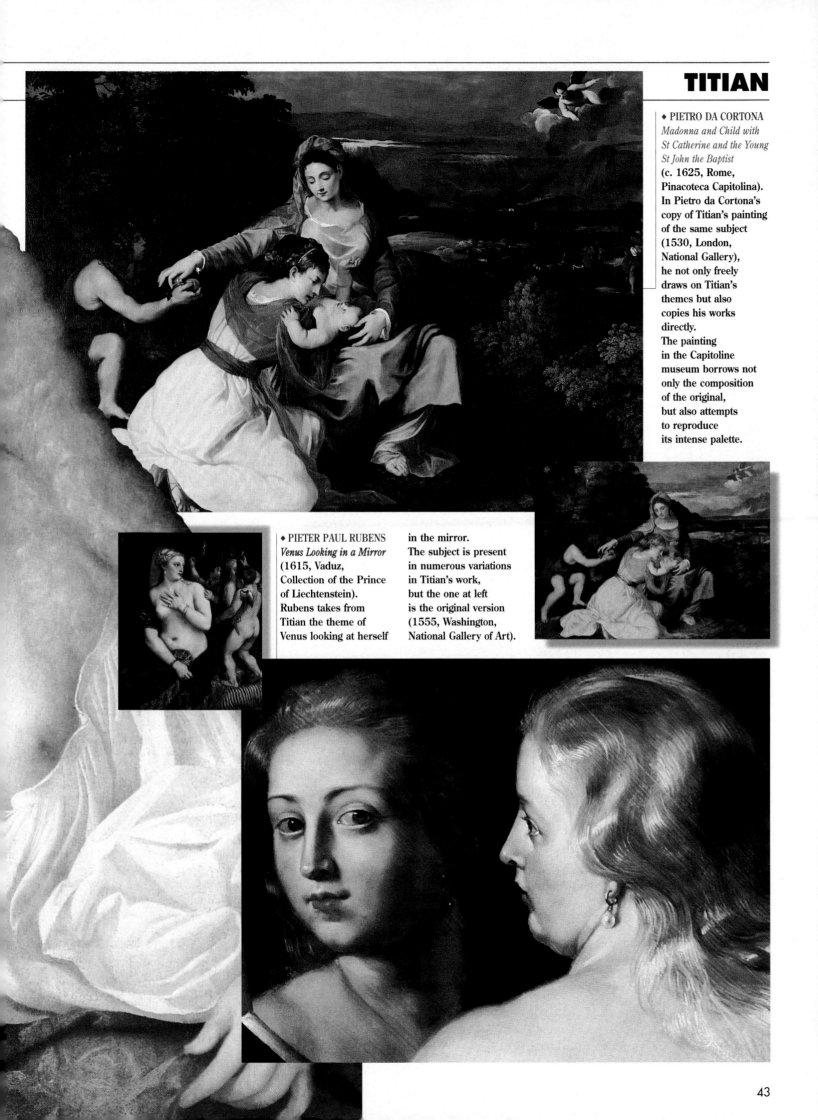

♦ **PIETRO DA CORTONA**
Madonna and Child with St Catherine and the Young St John the Baptist
(c. 1625, Rome, Pinacoteca Capitolina). In Pietro da Cortona's copy of Titian's painting of the same subject (1530, London, National Gallery), he not only freely draws on Titian's themes but also copies his works directly. The painting in the Capitoline museum borrows not only the composition of the original, but also attempts to reproduce its intense palette.

♦ **PIETER PAUL RUBENS**
Venus Looking in a Mirror (1615, Vaduz, Collection of the Prince of Liechtenstein). Rubens takes from Titian the theme of Venus looking at herself in the mirror. The subject is present in numerous variations in Titian's work, but the one at left is the original version (1555, Washington, National Gallery of Art).

THE ARTISTIC JOURNEY

To give a complete picture of the artistic personality of Titian,
we have compiled a summary of other works, in addition to those analyzed in the text

◆ ST PETER, ALEXANDER IV, AND BISHOP PESARO (1503-1507)

The altarpiece was painted to commemorate the role played by Bishop Jacopo Pesaro in the battle of Santa Maura, in which the Venetians won back the island from the Turks. Pope Alexander IV is shown as he entrusts the patron to the protection of St Peter, seated on a throne that rests on a base bordered by a classical relief.

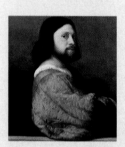

◆ PORTRAIT OF A MAN (ARIOSTO) (1508-11)

The painting in the National Gallery in London, erroneoulsy identified as the poet Ludovico Ariosto, is one of his youthful works most closely tied to Giorgione's models. Titian borrows the master's way of setting the sitter in perspective in a three-quarters position, without however giving him the psychological depth that would characterize his later portraits.

◆ PORTRAIT OF A LADY (LA SCHIAVONA) (1510-12)

Even though using a model established by Giorgione for portraits, Titian in this painting, now in London, inserts the interesting expedient of a marble slab on which is carved the classicizing female profile. The image exudes an air of undeniable dynamic energy and of earthly humanity, far removed from the generic pschological examination typical of Giorgione.

◆ THE MIRACLE OF THE JEALOUS HUSBAND (1511)

The painting is part of a fresco cycle for the Scuola del Santo in Padua, the artist's first documented work. Titian's loose brushwork dynamically conveys the violence of the scene. The fury of the jealous husband stabbing his wife, wrongly accused of infidelity, is mitigated by the figure of St Anthony who reassures the repentant murderer that his wife has been saved.

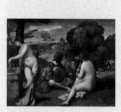

◆ THE OUTDOOR CONCERT (1511)

This canvas in the Louvre, attributed by some to Giorgione and others to Titian, presents a familiar subject, that of music in a landscape. It is an evident allusion to the musical harmony represented by the woman playing the flute, accompanying the young man on the lute, and its interruption by the shepherd on the right. The nude woman in the foreground seems to represent the Muse who tempers sounds.

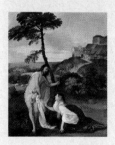

◆ NOLI ME TANGERE (c. 1512)

Attribution of the painting fluctuates between Giorgione and Titian. Current research assigns the work to the younger artist because of its perfect insertion of the religious subject into the warm tones of the landscape. It should be noted, in any case, that the group of houses on the right appears unchanged in one of Giorgione's masterpieces, *The Venus of Dresden*, in which Titian painted the landscape in the center.

◆ ALLEGORY OF THE THREE AGES OF MAN (1513-15)

This painting, now in Edinburgh, approaches *Sacred and Profane Love* in its clearly paratactical structure and its strongly allegorical content. The moral meaning, exemplified by the contrast of the pair of young lovers in the foreground with the old man meditating on death in the background, is expressed in the beautifully coloristic style of the artist's early period.

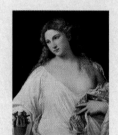

◆ FLORA (c. 1515)

Considered one of Titian's supreme masterpieces, the painting marks the zenith of the artistic development of his youthful phase, characterized by a classicism of pure form and color, obtained by the fusion of color and form. The female figure, identified as Flora, the wife of Zephyrus, clearly alludes to the sensual and erotic side of marriage.

◆ THE ASSUMPTION OF THE VIRGIN (1516-18)

The painting, placed over the high altar of the Franciscan church of Santa Maria dei Frari in Venice, was commissioned in 1516 by the prior of the convent Germano da Casale. The revolutionary innovations introduced by this painting made Titian the undisputed leader of Venetian painting but also naturally aroused contrasting reactions, ranging from the enthusiasm of the people to the perplexity of the patrons.

◆ THE WORSHIP OF VENUS (1518-19)

The painting is the first of a series of *Bacchanals* commissioned by Duke Alfonso d'Este for his alabaster chamber. The subject, perhaps chosen by the duke himself, is taken from an episode from the *Eikones* by Philostratus the Elder, in which he describes a painting of a festival of followers of Eros. The work, after coming to Rome as part of the Aldobrandini collection, was offered in 1639 to Philip IV of Spain.

◆ BACCHANAL (THE ANDRIANS) (1518-19)

Titian here has in mind another passage from Philostratus's *Eikones* (*Images*), describing another painting representing Dionysus as he arrives by sea on the island of Andros, where the inhabitants are waiting for him in a drunken state. In the work, now in the Prado where it came by way of the Aldobrandini collection, can be read a sheet of music with the song of the Andrians in French.

◆ THE AVEROLDI POLYPTYCH (1522)

The work, painted in 1522 for the papal legate Altobello Averoldi, was thought to be so beautiful that, despite the fact that it follows an outdated scheme, the fifteenth century polyptych, it attracted the attention of Alfonso d'Este, who wanted to purchase it. Titian succeeds in giving the painting unity through a dynamic use of light.

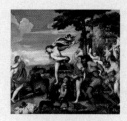

◆ BACCHUS AND ARIADNE (1522-23)

The final painting executed for Duke Alfonso's alabaster chamber represents the highest peak of Titian's chromatic classicism. The subject celebrates the newly rediscovered relationship between man and nature. It shows the meeting between Bacchus, just returned victorious from India, and Ariadne, abandoned on the island of Nexus by Theseus. The painting is now in the National Gallery in London.

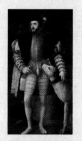

◆ PORTRAIT OF CHARLES V (1532-33)

The portrait in Madrid, one of the first the artist painted for Charles V, was probably made during the emperor's second stay in Bologna, as is confirmed by a passage from Vasari's life of Titian. The illustrious figure is shown standing with his hound, in an intimate attitude and not dressed in his official robes, quite differently from portraits of the sovereign in military regalia.

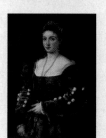

◆ LA BELLA (1536)

The painting, transferred to Florence with the Della Rovere estate in 1631, can be identified as the portrait of a woman "in a blue dress" cited by the duke of Urbino. Celebrated for its high stylistic quality, the work is famous also because of the beauty of the model, who appears in other works by Titian such as the *Venus of Urbino*, the *Girl with a Feather in her Hat*, and the *Girl in a Fur*.

◆ PORTRAIT OF FRANCESCO MARIA DELLA ROVERE (1536-38)

The painting, part of a pair with that of his wife, Eleonora Gonzaga, must be seen in conjunction with its preparatory drawing, now in the Gabinetto dei Disegni e delle Stampe of the Uffizi, where the duke is shown full length. According to Aretino, the analytical description of Francesco's armor is an expression of his inner gifts.

◆ PORTRAIT OF ELEONORA GONZAGA (1536-38)

The portrait of the duchess of Mantua cannot be separated from that of her husband, Francesco Maria della Rovere. The meticulous attention to the details of her dress, hairstyle, and jewels, probably derives from the fact that Titian was able to paint her during a number of sittings while she was staying in Venice. Notice especially the presence of the dog, a symbol of fidelity, and the clock.

◆ THE VENUS OF URBINO (1538)

The iconography of the reclining Venus undergoes a significant variation. The goddess has lost all reference to the landscape and surrounding nature associated with her in Giorgione's rendition, and assumes an air of intimate sensuality reflected also in the setting of the scene in an interior. The allusion to domestic happiness is given by the presence of the dog and the handmaidens in the background.

◆ PORTRAIT OF A MAN (THE YOUNG ENGLISHMAN) (1540-45)

The identity of the young man in this fascinating portrait – now in the Pitti – still remains unknown, although some scholars see here a connection to the young Aretino. The image stands out for the severe elegance of the black and gray tones of his clothing and his heroic stance, constructed with Titian's characteristic rapid, heavily laden brushstroke.

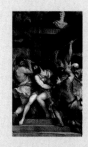

◆ CHRIST CROWNED WITH THORNS (1542-44)

Painted for the Milanese church of Santa Maria delle Grazie, this picture is an example of Titian's highly personal way of interpreting Roman mannerism. The accentuation of the musculature and the torsion of the bodies of the executioners, derived from classical statuary, are united with an intense play of light and shadow and a deliberate symmetry of composition.

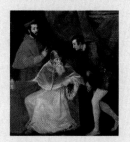

◆ POPE PAUL III WITH HIS NEPHEWS ALESSANDRO AND OTTAVIO FARNESE (1546)

This painting, now in the Capodimonte museum in Naples, was painted with Raphael's portrait of Leo X in mind. The elderly pope, bent with age, is shown with his nephews Alessandro and Ottavio. The suffocating, treacherous atmosphere of the papal court emerges from the attitudes of the persons surrounding the pope.

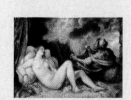

◆ DANAE (1553-54)

This painting in Madrid, commissioned by Philip II for the series of "poems" painted for him by Titian, is a slightly modified version of the painting made by the artist in 1546 for Alessandro Farnese. The subject is the myth of Danae who, although imprisoned by her father to prevent her from conceiving a grandson destined to kill him, was impregnated by Jupiter who came to her in the form of a shower of gold.

◆ SELF-PORTRAIT (c. 1562)

The self-portrait in Berlin is assigned by critics to the decade of the 1560s. The stylistic traits of the painting correspond with the painter's late manner, based on rapid brushwork vibrant with color and light. The pose of the figure and its placement in space, too, underline the inner psychological investigation of the late Titian.

◆ THE CROWNING WITH THORNS (c. 1570)

This work is a version of the earlier picture now in the Louvre, with significant stylistic variations. While the iconography of the two canvases is similar, the dense, pasty, almost dirty pigment imparts high drama to this new interpretation. This later picture, now in Munich, too, lacks all reference to the classical world, which had marked the culture of Roman mannerism.

◆ THE PUNISHMENT OF MARSYAS (1570-76)

This painting in Kromeriz represents the punishment of the satyr Marsyas, defeated by Apollo in a musical contest and sentenced to being flayed alive. The cruel depiction of the scene is achieved by modelling color and light to the point of a complete dissolution of the form. The master's late style expresses a tragic awareness of human destiny and suffering.

◆ PIETÀ (1576)

This canvas in Venice is Titian's last work, painted for his own tomb. Left unfinished at his death, it was completed by Palma the Younger. Defined as the painter's spiritual testament, the *Pietà* contains deeply felt autobiographical references: the figure of Nicodemus is a synthesized self-portrait of Titian, who also appears in the little votive panel at the bottom of the picture.

TO KNOW MORE

The following pages contain: some documents useful for understanding different aspects of Titian's life and work; the fundamental stages in the life of the artist; technical data and the location of the principal works found in this volume; an essential bibliography

DOCUMENTS AND TESTIMONIES

Titian, Philip and the "poems"

The relationship between Philip II and Titian is witnessed by an intense correspondence which they kept up for almost fifty years. This makes it possible to reconstruct the history of the artist's paintings commissioned by the Spanish king. The passages selected here refer to the "poems," a series of paintings on mythological subjects which were Philip II's special favorites.

Venice, September 10, 1554

My heart now comes to rejoice with Your Majesty for the new kingdom granted him by God, accompanied by the present painting of Venus and Adonis, which picture will I hope be seen by Your Majesty with those same glad eyes that Your Majesty has habitually turned on the things by your servant Titian. And because the Danae, which I have already sent to Your Majesty, was seen all from the front part, I have wanted in this other poem to do something different and show her from the opposite side, so that the chamber where they are to be put will be more pleasing to the sight.

From Venice on the 19th day of June of 1559

Most Indomitable Catholic King, I have already furnished the two poems dedicated to Your Majesty, one of Diana at the fount where she is reached by Actaeon, the other of Callisto pregnant by Jupiter undressed at the fount by command of Diana through her Nymphs. However, when it shall please Your Majesty to have them, send the command that you should have them, so that it will not happen to them what happened to the Dead Christ in the Tomb, which was lost on the journey.

Vasari's Praise

Admiration for Titian's art is found also in Giorgio Vasari's Lives, *where the Tuscan historiographer sings the artist's praises, despite the fact that the two figures belong to different cultural worlds, one Florentine and the other Venetian.*

Titian has been very sound in health, and as fortunate as any man of his kind has ever been; and he has not received from Heaven anything save favours and blessings. In his house at Venice have been all the Princes, men of letters and persons of distinction who have gone to that city or lived there in his time, because, in addition to his excellence in art, he has shown great gentleness, beautiful breeding, and most courteous ways and manners... Titian, then, having adorned with excellent pictures the city of Venice, nay, all Italy and other parts of the world, deserves to be loved and revered by the craftsmen, and in many things to be admired and imitated, as one who has executed and is still executing works worthy of infinite praise, which shall endure as long as the memory of illustrious men may live. Now, although many have been with Titian in order to learn, yet the number of those who can truly be called his disciples is not great, for the reason that he has not taught much, and each pupil has gained more or less knowledge according as he has been able to acquire it from the works executed by Titian...

Generous, courteous, perfectionist

The historiographer of Venetian painting Carlo Ridoli offers a carefully researched biography of Titian, filling the lacunae *left by the preceding artistic literature, especially that deriving from Vasari.*

No less did there shine in him greatness of spirit, as he kept in his house a worthy number of servants, and dressed splendidly like a great Knight; and in his trips, which he made to the courts of Princes, he always treated everyone with generous largesse; and it is said, that he received as unexpected guests at dinner the Spanish Cardinals Granvella and Pacecco, and throwing his purse to his servants said, prepare the meal, since I find myself with the whole world in my house, keeping them occupied in the meantime by touching up their portraits... nor was there Personage or Knight of importance in Italy or abroad who did not show him favors, and did not obtain some remembrance of his famous hand... He had courteous manners, and although he was not well lettered, he was gifted with natural talents, and by frequenting the Courts he learned every good Knightly term. He used to say that virtue, long possessed, was a particular grace from Heaven, but he never boasted of it ever, and invited by a painter to see a work he had done, only said, as he liked it, that it seemed from his own hand. He also said, that not everyone was able at painting, and that many were thwarted by the difficulties they encountered in Art. And that painting with violence, without the right talent, could only bring forth shapeless results, as this skill demands an undisturbed genius. That the Painter must always in his works look for the properties of things, forming ideas of his subjects that represent their qualities and the movements of their soul, that marvelously satisfy the observer, and that it was not colors which made figures beautiful, but good draughtsmanship; and although reduced to extreme old age and almost completely deprived of sight, imitating the famous Apelles he did not let a day go by without giving shape to something with charcoal or plaster... He used few colors imitating Giorgione, and in the clothing happily used red and blue, which never look bad on figures. He was also accustomed to keeping his paintings in his house for a long time, covering them when he had finished working on them, and after some time looking at them again, he almost always made them perfect...

1480-85. Between these two dates, Titian was born in Pieve di Cadore into a family of notaries.

1503. The small altarpiece for Jacopo Pesaro was probably started in this year. The work, finished in 1506, would thus be one of the earliest made by the artist for an illustrious patron like the Pesaro family.

1508. The frescoes, commissioned to Giorgione, for the facade of the Fondaco dei Tedeschi were begun in this year. Titian's presence is witnessed by Vasari and Dolce.

1511. Titian painted a fresco cycle for the Scuola del Santo in Padua.

1516-18. In 1516 the artist's relationship with Alfonso I d'Este began. In that same year Germano Casale commissioned him to paint the altarpiece of the Assumption for the Franciscan church of Santa Maria dei Frari. In 1518 the work was set in a marble altar, as the high altar of the church.

1519-26. His relationship with the Pesaro family continued with the commission for a painting representing a *Sacra Conversazione* to be placed on the altar of the Immaculate Conception.

1522. Painted the polyptych for the church of Santi Nazzaro e Celso for the Papal Legate Averoldi.

1523. Beginning of his relationship with Federico Gonzaga and the court of Mantua; relations with Ferrara intensified.

1525. Married Cecilia; from their union were already born two sons, Pomponio and Orazio.

1527. Fleeing the Sack of Rome, Aretino, Sansovino, and Sebastiano del Piombo arrived in Venice.

1530. For the coronation of Charles V, Titian went to Bologna where he painted the first portrait of the new emperor.

1532. Beginning of his relationship with Francesco Della Rovere, duke of Urbino. The following year he was back in Bologna to paint the second portrait of Charles V. On this occasion he received benefits and honors from the emperor.

1541. In the course of this year, relationships with Charles V intensified. Painted *Allocution* for Alfonso d'Avalos, *marchese* of Vasto and the emperor's general, receiving a pension of 100 ducats from Charles V.

1544. Finished three paintings of Bible subjects for the ceiling of the church of Santo Spirito in Isola.

1545. In October went to Rome where he was welcomed cordially by Bembo, Cardinal Alessandro Farnese, and Paul III himself. Met Michelangelo and was taken to see the most important monuments in the city. Painted for Ottavio Farnese the *Danae* now in Capodimonte and for Paul III his portrait with his nephews.

1548. In January Titian went to the Diet of Augsburg with his son Orazio and grandson. On this occasion painted the portraits of numerous princes and of the emperor Charles V.

1551. Painted various works for the emperor's circle, among them the portrait of prince Philip, the beginning of a long friendship which would last until the artist's death.

1552. Beginning of his long correspondence with Philip, preserved in the archives of Simancas.

1554. For the wedding of Philip II to Mary Tudor, Titian sent *Venus and Adonis* to England.

1555. Painted the portrait of Doge Francesco Venier. In that same year, Charles V abdicated, taking with him to Yuste *The Adoration of the Holy Trinity*.

1559. Sent to Philip II the "poems" *Diana and Actaeon* and *Diana and Callisto*, and *The Entombment*.

1564. Sent to Philip II *The Rape of Europa* and *Christ Praying in Gethsemane*.

1567. At the end of the year sent *The Martyrdom of Saint Lawrence* to Philip II.

1568. Painted the portrait of Jacopo Strada, antiquarian and collector for the Hapsburgs, begun the preceding year.

1571. Sent to Philip II the painting of *Tarquin and Lucretia*. Also sent a letter to the emperor complaining of not having received payment for the pictures sent.

1576. Titian's last letter asking for payment is dated February 27. On August 27 he died in Venice of the plague and was buried in the church of the Frari.

The following is a catalogue of the principal works by Titian conserved in public collections. The list of works follows the alphabetical order of the cities in which they are found. The data contain the following elements: title, dating, technique and support, size in centimeters, location.

ANTWERP (BELGIUM)
St Peter, Alexander VI and Bishop Pesaro, 1503-07; oil on canvas, 145x183; Musée Royal des Beaux-Arts.

CAMBRIDGE (GREAT BRITAIN)
Tarquin and Lucretia, 1571; oil on canvas, 188x145; Fitzwilliam Museum.

DRESDEN (GERMANY)
Sleeping Venus (Venus of Dresden), 1510; oil on canvas, 109x165; Gemäldegalerie.

EDINBURGH (GREAT BRITAIN)
Allegory of the Three Ages of Man, 1513-15; oil on canvas, 109x165; National Gallery of Scotland.

FLORENCE (ITALY)
The Concert, 1512; oil on canvas, 108x122; Palazzo Pitti.

La Bella, 1536; oil on canvas, 100x75; Palazzo Pitti.

Portrait of a Man (the Young Englishman), 1540-45; oil on canvas, 111x93; Palazzo Pitti.

Flora, c. 1515; oil on canvas, 79x63; Uffizi.

Portrait of Francesco Maria della Rovere, 1536-38; oil on canvas, 115x100; Uffizi.

Portrait of Eleonora Gonzaga, 1536-38; oil on canvas, 114x102; Uffizi.

Venus of Urbino, 1538; oil on canvas, 119x165; Uffizi.

KROMERIZ (CZECH REPUBLIC)
The Punishment of Marsyas, 1570-76; oil on canvas, 212x207; National Museum.

LONDON (GREAT BRITAIN)
Portrait of a Man (Ariosto), 1508-11; oil on canvas, 81x66; National Gallery.

Portrait of a Lady (La Schiavona), 1510-12; oil on canvas, 117x97; National Gallery.

Noli me tangere, c. 1512; oil on canvas, 109x91; National Gallery.

Bacchus and Ariadne, 1522-23; oil on canvas, 175x190; National Gallery.

Votive Portrait of the Vendramin Family, 1543-47; oil on canvas, 206x301; National Gallery.

MADRID (SPAIN)
The Worship of Venus, 1518-19; oil on canvas, 172x175; Prado.

Bacchanal (The Andrians), 1518-19; oil on canvas, 175x193; Prado.

Portrait of Charles V, 1532-33; oil on canvas, 192x111; Prado.

Allocution of Alfonso d'Avalos, 1540-41; oil on canvas, 223x165; Prado.

Portrait of Charles V on Horseback, 1548; oil on canvas, 332x279; Prado.

Venus and Adonis, 1553; oil on canvas, 186x207; Prado.

The Adoration of the Holy Trinity, 1551-54; oil on canvas, 346x240; Prado.

The Entombment, c. 1566; oil on canvas, 130x168; Prado.

Self-portrait, c. 1567; oil on canvas, 86x65; Prado.

MUNICH (GERMANY)
Charles V, 1548; oil on canvas, 205x222; Bayerische Staatsgemäldesammlungen.

Christ Crowned with Thorns, 1570; oil on canvas, 212x207; Bayerische Staatsgemäldesammlungen.

NAPLES (ITALY)
Paul III with his Nephews Alessandro and Ottavio Farnese, 1546; oil on canvas, 210x174; Gallerie di Capodimonte.

Danae, 1545-46; oil on canvas, 120x172; Gallerie di Capodimonte.

PARIS (FRANCE)
The Outdoor Concert (Fête Champêtre), 1511; oil on canvas, 110x138; Louvre.

The Young Woman Looking in a Mirror, 1512-15; oil on canvas, 96x76; Louvre.

Portrait of a Man with a Glove, c. 1523; oil on canvas, 100x89; Louvre.

Madonna and Child with St Catherine and the Young St John the Baptist, 1530; oil on canvas, 71x85; Louvre.

Antiope Surprised by Jupiter, 1540; oil on canvas, 196x385; Louvre.

Christ Crowned with Thorns, 1542-44; oil on canvas, 303x180; Louvre.

ROME (ITALY)
Venus Blindfolding Cupid, 1565; oil on canvas, 118x185; Galleria Borghese.

VENICE (ITALY)
The Presentation of Mary in the Temple, 1534-38; oil on canvas, 345x775; Gallerie dell'Accademia.

Pietà, 1576; oil on canvas, 335x348; Gallerie dell'Accademia.

VIENNA (AUSTRIA)
Portrait of Isabella d'Este, 1534-36; oil on canvas, 102x64; Kunsthistorisches Museum.

Portrait of a Girl in a Fur, 1535-37; oil on canvas, 95x63; Kunsthistorisches Museum.

Portrait of Benedetto Varchi (?), 1550; oil on canvas, 117x91; Kunsthistorisches Museum.

Portrait of Jacopo Strada, 1567-68; oil on canvas, 125x95; Kunsthistorisches Museum.

WASHINGTON (UNITED STATES)
Portrait of Cardinal Pietro Bembo, 1540; oil on canvas, 95x77; National Gallery of Art.

Portrait of Doge Andrea Gritti, 1540; oil on canvas, 133x104; National Gallery of Art.

BIBLIOGRAPHY

The bibliography on Titian is of course endless, and we limit ourselves here to indicating the most important works, the catalogues of exhibitions, and the most recent publications.

1964 A. Morassi, *Tiziano*, Milan

1969 R. Pallucchini, *Tiziano*, 2 vols., Florence

F. Valcanover, *L'opera completa di Tiziano*, Milan

E. Panofsky, *Problems in Titian. Mostly iconographic*, London

1969-80 H.E. Wethey, *The Paintings of Titian*, London

1970 L. Venturi, *La via dell'Impressionismo*, Turin

1980 A. Gentili, *Da Tiziano a Tiziano*, Milan

C. Hope, *Titian*, London

1983 D. Rosand, *Tiziano*, New York

The Genius of Venice, 1500-1600, exh. cat., London

1990 *Tiziano*, exh. cat., Venice

1993 *Le siècle du Titian*, exh. cat., Paris

1996 *Amor sacro e Amor profano*, exh. cat., Rome

ONE HUNDRED PAINTINGS:

every one a masterpiece

—— **Also available:** ——

*Raphael, Dali, Manet, Rubens,
Leonardo, Rembrandt, Van Gogh,
Kandinsky, Renoir, Chagall*

Vermeer
The Astronomer

Titian
Sacred and Profane Love

Klimt
Judith I

Matisse
La Danse

Munch
The Scream

Watteau
The Embarkment for Cythera

Botticelli
Allegory of Spring

Cézanne
Mont Sainte Victoire

Pontormo
The Deposition

Toulouse-Lautrec
At the Moulin Rouge

—— **Coming next in the series:** ——

*Magritte, Modigliani, Schiele,
Poussin, Fussli, Bocklin, Degas,
Bosch, Arcimboldi, Redon*